THE PATH
to
FREEDOM

THE PATH *to* FREEDOM

Black Families in New Jersey

Walter D. Greason

Charleston · London

THE
History
PRESS

Published by The History Press
Charleston, SC 29403
www.historypress.net

First published 2010

Manufactured in the United States

ISBN 978.1.59629.992.4

Library of Congress Cataloging-in-Publication Data

Greason, Walter.
The path to freedom : Black families in New Jersey / Walter Greason.
p. cm.
Includes bibliographical references.
ISBN 978-1-59629-992-4
1. African American families--New Jersey--History. 2. African Americans--New Jersey--
History. 3. African Americans--Segregation--New Jersey--History. 4. African Americans--
New Jersey--Social life and customs. 5. African Americans--New Jersey--Biography. 6. New
Jersey--Race relations. I. Title.
E185.93.N54G73 2010
305.896'07309749--dc22
2010024439

Contents

ACKNOWLEDGEMENTS

The number of people who have contributed to the completion of this project extends into multiple hundreds, so I begin with a simple "thank-you" to everyone who advised, edited, suggested or encouraged my study of New Jersey over the last fifteen years. Colleagues in that pursuit included Clement Price, Bettye Collier-Thomas, Kenneth Kusmer, Wilbert Jenkins, Teshale Tibebu, William Carrigan, Karl Johnson, David McAllister, Patricia Hampson, Daniel Wolffe, Helen Chantal-Pike, Lee Ellen Griffith, Randall Gabrielan, Giles Wright and Helen Elliott. My interview subjects who were so generous with their time and memories shaped the core content for my interpretations and analysis. Without them, any understanding of the black communities in New Jersey (especially outside of the major cities) would have been impossible. John Strassburger, Judy Levy, Dallett Hemphill, Hugh Clark, Ross Doughty and Charles Rice all provided crucial support for my work through various grant programs and other academic insights. Special thanks go to the Ham family of Monmouth County for their singular generosity in preserving forgotten aspects of African American history through the creation and maintenance of the Court Street School Education Community Center and Bethel AME Church in Freehold, New Jersey. My wife, Janiece, and son, Duende, provide love and stability that every person would be lucky to possess. Ultimately, all glory belongs to God in this project and all other areas of my life. Only the mistakes are mine.

INTRODUCTION

When the historian and sociologist William E.B. DuBois wrote about the importance of pride in the African American community in the *Crisis* magazine in 1933, he addressed the pressing poverty, unemployment, segregation and discrimination that taught black people to be ashamed of themselves:

> *American Negroes will be beaten into submission and degradation if they merely wait unorganized to find some place voluntarily given them in the new reconstruction of the economic world. They must themselves force their race into the new economic set-up and bring with them the millions of West Indians and Africans by peaceful organization for normative action or else drift into greater poverty, greater crime, greater helplessness until there is no resort but the last red alternative of revolt, revenge, and war.*

New Jersey was a terrain for advocates for racial equality, ranging from Florence Randolph (pioneering pastor of Wallace Chapel AME Zion Church in Summit, New Jersey) to George White (United States congressional representative, 1897–1901, and founder of Whitesboro, New Jersey) to Caleb Oates (pastor of Bethany Baptist Church in Farmingdale, New Jersey, and founder of the Monmouth Community Action Program). These leaders and their communities transformed democracy in the Garden State during the twentieth century. Their legacy inspires new achievements as the bounty of human freedom.

In 1900, most people in Europe and the United States considered African American history an oxymoron. The idea of Africa embodied the absence of progress or civilization. Thus, there was no history there or among anyone descended from that region. Religious and scientific arguments ranging from the Curse of Ham to craniology reinforced the social perceptions of black inferiority. While many of the obvious clashes about the humanity of Africans and African Americans unfolded in the rural South or the urban North between 1890 and 1930, some black families moved into western states or the rural communities of the North. Such black families in New Jersey believed that they could find a greater measure of freedom in small farming villages that permitted homeownership and educational achievement within the boundaries of the national system of Jim Crow segregation. In towns like Freehold, Asbury Park, Willingboro and Montclair, African American migrants crafted lives that their parents and grandparents could only imagine while living in southern states like Georgia, North Carolina and Virginia. By 2000, the great-grandchildren of these migrants routinely graduated from integrated high schools and colleges, worked in corporations and government offices and traveled across the nation and around the world at their leisure.

This transformation is the embodiment of human history. Understanding change over time is one of the most important purposes of studying the past. When racial slavery and subordination became a part of human civilization in the fifteenth and sixteenth centuries, it created a barrier to human advancement that had antecedents only in the treatment of religious minorities and women. For a people degraded as chattel property to escape that status and achieve a substantial degree of social and political equality within a century's time spoke to the simultaneous greatness of the liberal idea of human freedom and of the dogged persistence among people of African descent in western society. The study of African American history offers the lessons of freedom, dignity, integrity and authority to every student who considers it. In a world where terrorism looms wherever resentment festers and fascism lurks in anticipation of restricting freedoms in exchange for safety, the story of black families in New Jersey presents an alternative narrative to violent resistance and expansive domination.

The images that follow this introduction present a people who knew poverty intimately for multiple generations. They physically migrated to new homes throughout the twentieth century until they found places where their success would be tolerated, if not nurtured. They psychologically adapted themselves and their children to the methods of achieving an equality that the

society at large believed was impossible. Work hard, seek higher education, be thrifty, organize the community, assert your humanity and earn rest and respect in your later years. These steps carried families, households and whole towns to the realization of racial integration as a reality at the start of the twenty-first century.

Historian Andrew Wiese wrote,

> *In the years before 1950, thousands of central city blacks moved to the suburbs. Long ridiculed as "poverty pockets" and "suburban slums," the communities where they settled were often poor, but they were fully part of the national trend toward urban decentralization known as suburbanization. At the same time, they reflected a vision of residential, family, and community life that was at once suburban, working-class, and African American. This vision, as much as economic necessity, shaped the landscape of American suburbia in the same fashion as the well-documented dreams of middle class whites.*

The formal portraits and informal snapshots that appear on the following pages both confirm and complicate Wiese's assertion. African American migrants to New Jersey were an integral part of the farm labor force that created the idea of "the Garden State"—an idyllic space located between the industrial cities of New York and Philadelphia. Yet they were arguably the most important residents because their work to expand the promise of democracy for all people created the spaces for Asian, Latino and African immigrants to energize the state's service economy and suburbs as the twenty-first century began.

This book draws from an enormous private collection of photographs created by Nicy Marion Ham Russell between 1935 and 1995. There are more than three thousand images that connect the Civil War and Reconstruction era to the emergence of popular culture and music through jazz, disco and hip-hop. The majority of the collection is available for researchers through the Court Street School Education Community Center in Freehold, New Jersey. As a photographic history, it follows in the footsteps of Lee Ellen Griffith, Randall Gabrielan and Helen Chantal-Pike in presenting an important range of perspectives on the history of New Jersey. However, it relies on the professional historiography provided by hundreds of historians, sociologists and literary theorists to analyze the individuals, families and communities in both national and international context. *The Path to Freedom: Black Families in New Jersey* simultaneously shows the greatest

success and failure of American society in the twentieth century. "We hold these truths to be self-evident that all men are created equal." "Nor shall any State…deny to any person within its jurisdiction the equal protection of the laws." "The right…to vote shall not be denied…by any State on account of race, color, or previous condition of servitude." We must always sustain our Declaration of Independence and the Constitution of the United States.

Chapter 1

EARLY MIGRANTS

B etween the individual and the state as foundations of the liberal
democratic system, there are two institutions essential to the function of
both entities. Family and community constitute the dynamic arenas where
the formal and informal practices of human development intersect both
public and private ideology and action. Parents introduce the first ideas
about the world to their children. Children's experiences in society reshape
parents' ideologies about economics, culture and politics.

The branches of extended families—uncles, aunts, cousins, grandparents,
nieces and nephews—support flexibility and adaptation to the unintended
consequences of public policy and relationship instabilities. In many ways,
family and community are the manifestation of Adam Smith's invisible hand
that guides and dictates market conditions in civil society. The connection
of the individual to the family sets the priorities for accomplishment and
neglect on a day-to-day basis throughout human history.

Families replicate this outreach by networking with one another to form
communities. Communities then form the basis for stable politics and,
ultimately, the identity of nation-states. The family remains one of the most
fluid and dynamic social processes in human history.[1]

In the twentieth-century United States, the transition from marginal
political entity in world affairs to ideological leader of the industrialized world
reflected the demographic transformation of family units over the century.
When the children of farmers traveled to the cities in search of better pay,
their priorities reflected the limited opportunities of the nineteenth-century
agricultural economy.

These same individual decisions influenced the creation of four generations of urban American families that required standardization, advertising and material comfort at levels never imagined by their parents or grandparents. The urban American family dreamed new horizons of global accomplishment for their nation, and their work made those dreams into realities for their descendants between 1890 and 1950. No state illustrated this process more vividly than New Jersey. Newark, Trenton, Paterson, Camden and Atlantic City all experienced economic booms during the first half of the twentieth century.

The industrial prosperity of the Garden State never eclipsed its farming roots because Philadelphia and New York remained the dominant manufacturing centers. Yet the industrial framework remained too small to contain the ambitions of New Jersey's urban families. As the United States developed the industrial production capacities of European and Asian nations between 1950 and 1960, urban families began a migration to rural communities that would realize their parents' dreams.[2]

New Jersey became the suburban heart of the global, post-industrial, service economy. Desiring white-collar jobs, automobile comfort and technological homesteads, sprawl became the core character of the entire northeastern region of the United States. Once again, family priorities and mobility dictated the public policy of land use and the economics of corporate globalization.

The intersection of social forces like policy and economics has its own intimate character through the stories of Bill, George and Walter Ham in contrast with the life of Wendell Russell. North Carolina lay at the heart of the Old South in some ways, but it also had sharp differences from neighboring states like Virginia, Tennessee and South Carolina.

The Ham family in New Bern, North Carolina, did not experience the worst days of racial terrorism at the end of the nineteenth century and the beginning of the twentieth century. However, the daily indignity of compliance and survival within a system of racial peonage still took its toll. All of the sons shared dark complexions, but their personalities varied significantly.

William was a quiet and confident young man whose ambition shone in his eyes and smile. His charm carried through his voice and reinforced a subtle masculinity that attracted many friends throughout his life.

George was the biggest of the three brothers. He excelled in both his work and his athletic pursuits, but he did not share Bill's quick wit. He told more tall tales and could stare down a man even larger than he was. These abilities

covered a nurturing, gentle side of his character that all of the children in the family experienced at one time or another. George enjoyed his life the most of the three men, as he traveled and partied across the United States and into Canada. Freedom was a bounty that he relished after moving north. Together, Bill's and George's lives revealed the immediate sense of liberation that participants in the Great Migration felt between 1920 and 1960. Even in the segregated parts of the North, there was a sense of relief, a burden that lifted once an African American left his or her ancestral homes in southern states like North Carolina.

Walter, on the other hand, did not indulge in the easier paths to recreation and immediate satisfaction that his brothers enjoyed through the middle of the twentieth century. He was more humble, slower in both word and action than George or Bill. He was the smallest of the three but probably the toughest. Walter eschewed city living and distant travel for most of his life. Family was his highest priority, and he worked constantly to assure his children's education and stable home life. His story is one of the most overlooked narratives of the black freedom struggle. Walter was never elected to political office, never started a civil rights organization and never worked a job more prestigious than janitor at the local high school. Like most African Americans who left the South in the first half of the twentieth century, he understood the limitations that segregation imposed on his generation, and he crafted a path to overcome those obstacles for his children. In return, Walter's children laid the foundation for the regional and national civil rights victories that transformed American democracy in the second half of the twentieth century.

Wendell Russell is the first member of the civil rights generation considered in this book. He was a child of privilege raised in a relatively integrated setting in Ohio. His early life draws a number of distinctions when compared to the Ham brothers from North Carolina. Complexion was the most immediate advantage his family enjoyed. In a world where white skin was the singular measure of social, political and economic inclusion, being an African American with a light complexion carried the advantages of easier work, higher pay and access to more education. His parents, grandparents and great-grandparents had all owned their homes. They had all completed more than an elementary school education. These accomplishments enabled the creation of a family legacy of dignity and self-worth that developed a fundamental confidence for young Wendell. Over the course of his life, his self-confidence served him well, especially in the military. In many ways, he lived the life that the Ham brothers aspired to experience from the day he was born.

Social change revolved around questioning race in the twentieth-century United States. The Great Migration of black families to northeastern cities began after the Civil War. Several generations of migrants sought better communities as they relocated.

Whether in the form of riots or jazz compositions, interracial contact changed dramatically between 1890 and 1930. White supremacy maintained its ideological sway over the majority of Americans for many of those years. This inequality depended on a resistance to the Declaration of Independence's promise of equality. The limitations on black families' material wealth came from pervasive commitments to Jim Crow segregation.

Instead, the promise of equality became the foundation of their dreams. Black migrants to Morristown, Long Branch and Willingboro left behind labor as sharecroppers and nursemaids in favor of being day laborers and live-in domestics.

Segregated churches and schools provided the foundation for black towns that embodied the challenge to racial segregation. Civil rights organizations like the National Association for the Advancement of Colored People and the National Urban League emerged and took root in these areas.

African American families could not rely on voting rights and business ownership like European immigrants. Instead, their religious faith and lawsuits sustained their path to freedom. Black children gained their first access to integrated schools after 1950. The sacrifices African Americans made to reshape public policy and economic opportunity is the best example of nonviolent political reform in modern history.

The black reunion tradition that emerged after 1870 enabled African Americans to aspire to new dreams for the first time in nearly two centuries. The next three generations continued this process as the entire United States grappled with the meaning of race and citizenship in the first half of the twentieth century. Families were the site where values translated into behaviors in the service of black survival and success.

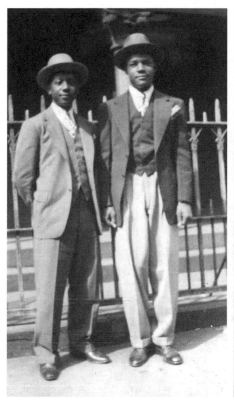

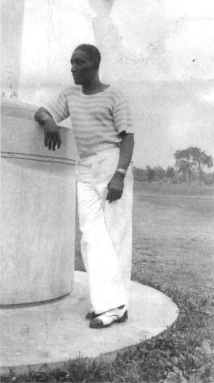

Above left: Bill Ham and one of his friends enjoyed the sunshine after church services one afternoon.

Above right: George Ham posed by a statue for a profile photo. His sense of style and confidence dominated the scene, even as he looked away from the camera.

Right: George was always a socialite in the family, as this image at the shore illustrates. Throughout his life, travel formed a crucial part of his idea of freedom—as it did for many African American families nationwide.

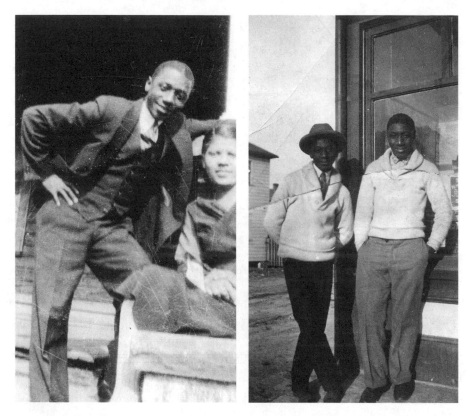

Above left: Bill was not to be outdone by his cousin. In his Sunday best, he also showed his charisma to friends and family from an early age.

Above right: Bill and George as young men in the South. They had the shine of ambition in their eyes, but could they have known how far their dreams would take them?

Opposite page: Bill as a young man in a more formal portrait. His suit and the background showed his early desire to present himself as a respectable member of American society.

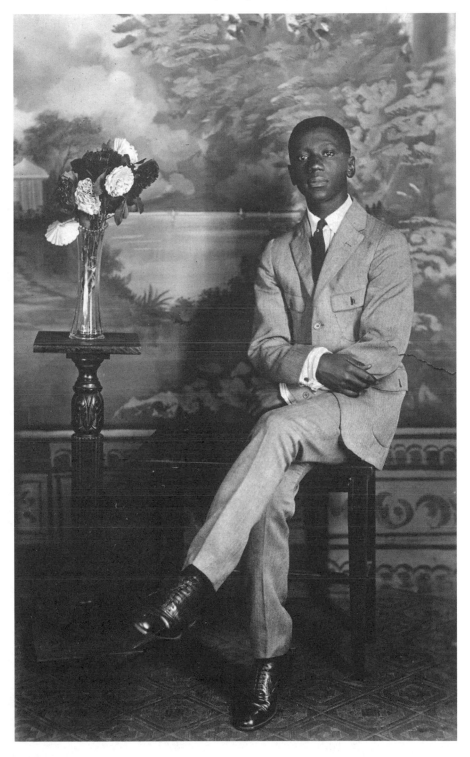

Mr. and Mrs. Lucas Ham

request the honor of your presence at the marriage
of their daughter

Louisa Elizabeth

to

Mr. Frederick Edward Anderson

on Thursday evening, the fourth of August

one thousand nine hundred and twenty-one

at eight o'clock

at 13 Elm Street

New Bern, North Carolina

Reception
from 8:30 till 11 o'clock

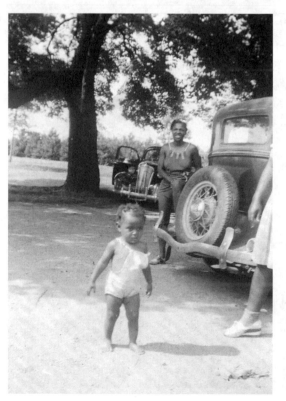

Above: When Louise married Fred in 1921, formal calligraphy on the invitation was a significant marker of the importance of the event and the social standing of the family. None of the later weddings in New Jersey preserved the same kind of documentation.

Left: A rare image of one of the toddlers before the family began the trip north to New Jersey.

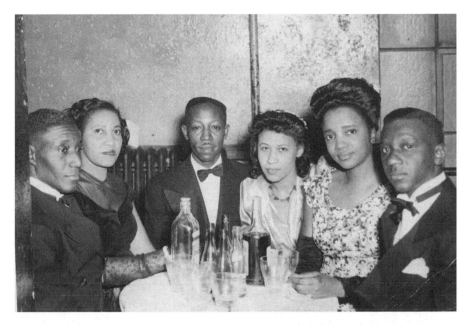

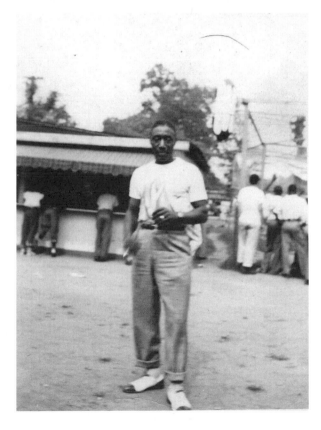

Above: George and Bill carried the air of quiet dignity and confidence at their senior prom in North Carolina.

Right: At the fair, George Ham stopped to enjoy a moment with his family. These kinds of moments were precious to African American families whose work often prevented frequent excursions and recreation.

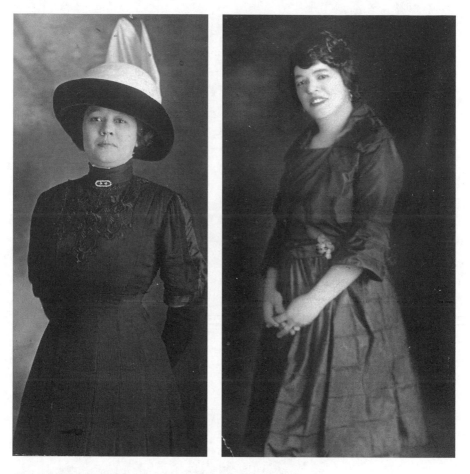

Above left: Portraits like this one of Wendell Russell's mother provided a non-verbal assertion of African American equality and dignity. Before 1930, a simple look or word of assertiveness from an African American was sufficient justification for law enforcement or the mob to destroy a life, a family or a community. The Russell family, even though possessing fair complexions, could only present these kinds of images within the privacy of their home.

Above right: This image is an early photo of Wendell's mother. The portrait undermines presumptions about African Americans generally and African American women in particular. Many political leaders and scholars asserted that black women lacked the dignity and restraint necessary to achieve true womanhood. Portraits like this one documented the existence of personal and social standards among African Americans that contradicted those fallacies.

Early Migrants

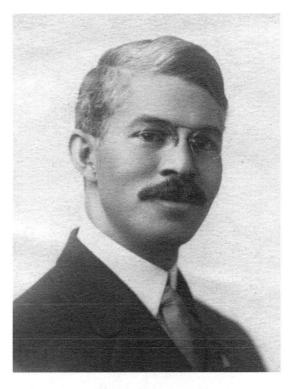

Here is an early portrait of Wendell's father. His presentation for the photo in a suit and tie with a pressed white shirt reveals the existence of black middle class and elite ideas about the importance of family.

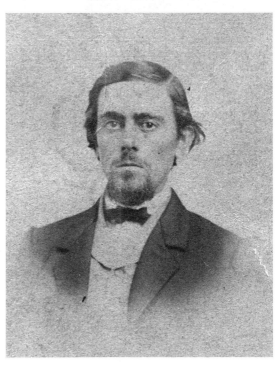

A daguerreotype of Wendell's grandfather dating back to circa 1875.

The series of photos of Wendell Russell as a child speak to the importance of the future to black families across the state. Parents believed that their children had a chance to achieve their dreams in ways that their lives, not to mention their parents' and grandparents' lives, had been circumscribed by racial segregation and slavery.

Wendell stood in the family garden behind the home with his cat. In bare feet and a light cloth outfit, he illustrates the lack of children's clothing for many rural African American families in the early twentieth century. The home in the background is also representative of the type of housing many rural migrants to New Jersey occupied when they arrived between 1885 and 1920.

Wendell as an infant.

Wendell, age two.

Wendell at age four. The photographer begins to provide backgrounds for these portraits that situate Wendell in an ideal suburban setting. His family also begins to dress him in ways that teach him about the proper ways to be a man.

Wendell at age five.

Early Migrants

Wendell at age seven. Standing before a bench and an image of the rural South, Wendell wore a suit much more suited to the larger cities of the North at the time. This portrait captures the social intersection that shaped the lives of black migrants in the first half of the twentieth century—the fading memories of the South and the aspirations to full equality and inclusion in the North.

Wendell at age one in overalls.

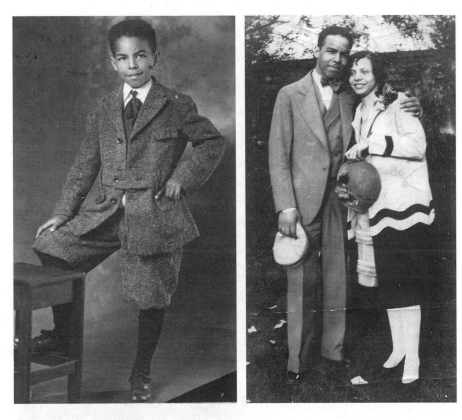

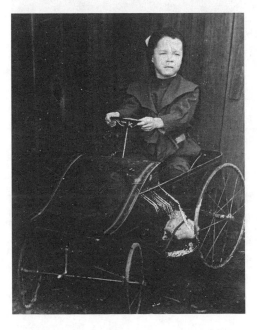

Above left: Wendell at age eleven. His pose revealed a growing confidence based on the security and safety he knew as a child.

Above right: Wendell and an early girlfriend posed for a snapshot before going out for the afternoon. The standards of attire for the event reveal the expectations for courting among African Americans between 1920 and 1930.

Left: Wendell's sister sat on a four-wheeled toy vehicle. Bicycles and other children's transportation were one of the earliest prized possessions for working-class children of all races. Her clothing shows the dignity and propriety even young girls had to communicate in order to maintain the social expectations of femininity and womanhood.

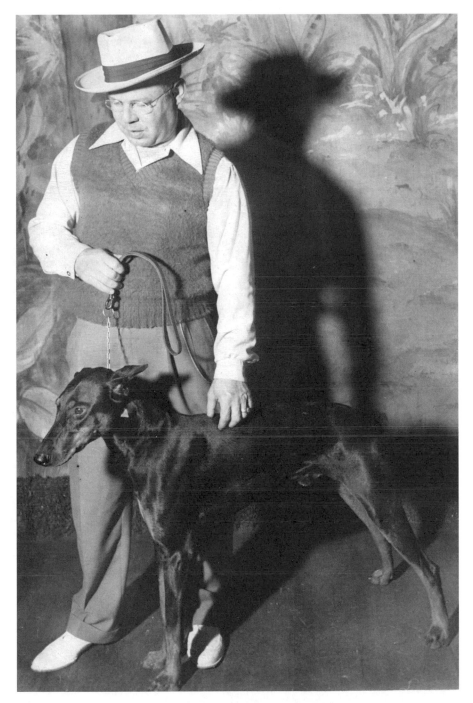

The patriarch of the Russell family loved his dog. He brought the pet into a formal photography shoot to reinforce his status as the leader and defender of the family, in line with early twentieth-century beliefs about men's roles in the house.

Again, the way Wendell's father stands in his yard with a Doberman pinscher showed both his authority and the family's status.

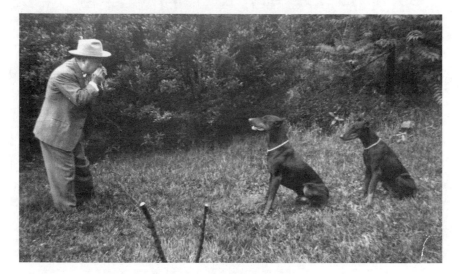

The image of Wendell's uncle whistling at the dogs as they sit attentively and await a command reinforces the idea of control and discipline at the heart of middle-class aspirations to social inclusion and respectability.

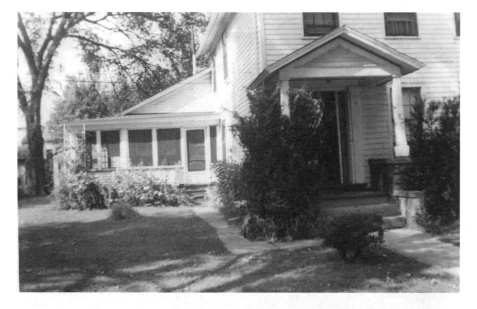

Above: The Russell family home, circa 1950. The two-tiered house with an enclosed back porch showed the improved access to housing that the family acquired as Wendell got older. These kinds of economic and social advancements by black families occurred in small communities throughout the northeastern and midwestern United States.

Right: Wendell in middle age, while dating Marion Ham.

Marion Ham and Wendell's mother in the home Wendell purchased for Marion. There is a palpable tension between the two women in this snapshot.

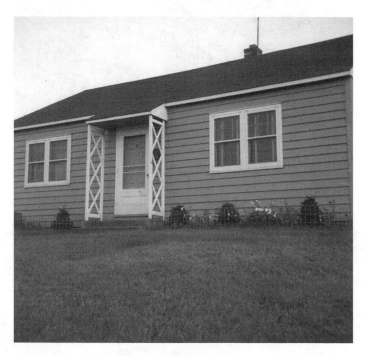

Wendell purchased a home in Freehold, New Jersey, after marrying Marion Ham. It was a ranch home with two bedrooms and a single bathroom. He would later add a large dining room by extending the house into the backyard.

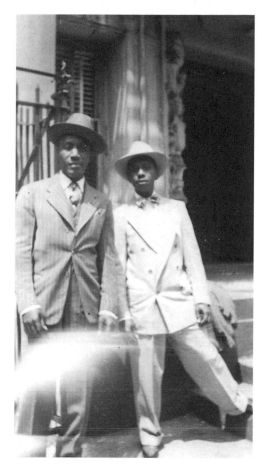

George Ham and his son posed for the camera in front of the church. The contrast between their formal clothing and the styles Wendell Russell's family wore marked geographical, social class and complexion differences between the two families

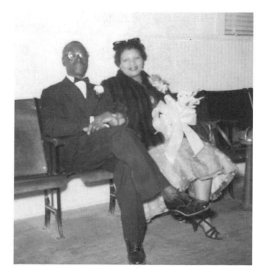

Walter and Lilla Ham sat on a pew in the church before a Sunday school program with their children began.

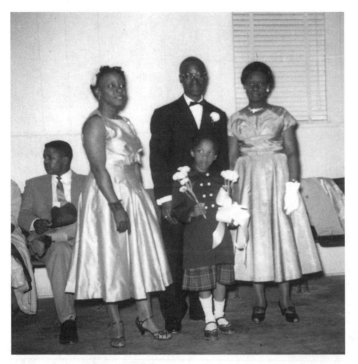

Walter stood with three of his five daughters at Leona Ham's wedding.

Lilla sat with her daughter Katherine's husband, Themer.

Early Migrants

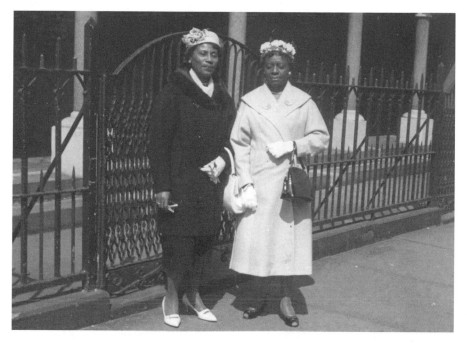

Two women of the church showed the dignity and piety of African American womanhood in the mid-twentieth century.

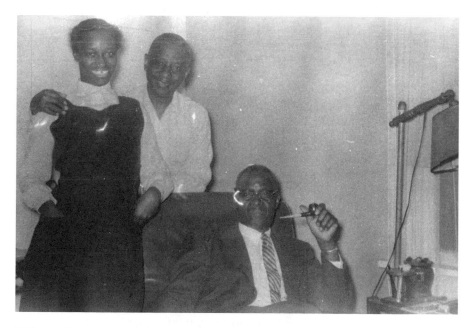

Walter sat in his reclining chair, while his cousin, Bill, hugged his youngest daughter, Wilma.

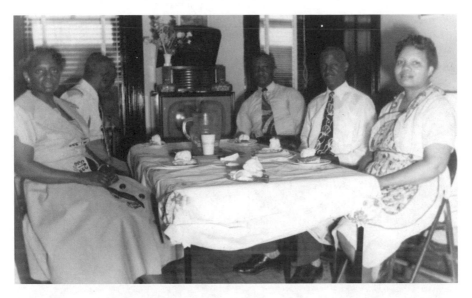

Bill Ham's family gathered around the table for Sunday dinner. Separate dining rooms were rare in these households before 1950, so folding tables in the living room were necessary.

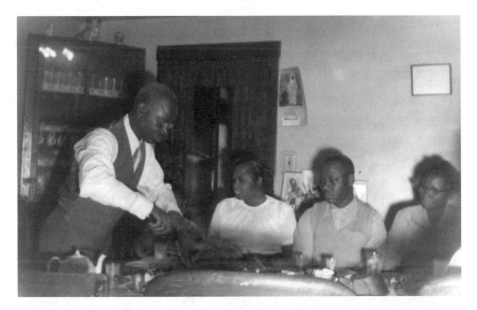

Bill's father cut the turkey and began the dinner.

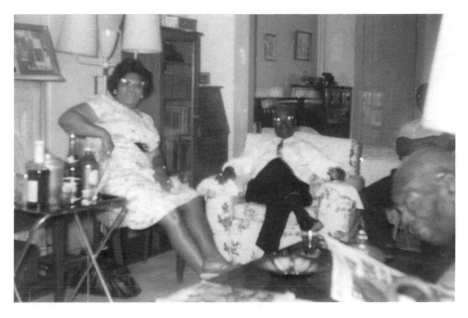

Walter and one of his cousins sat in the living room after dinner. The smaller spaces did not prevent African American families from furnishing the rooms thoroughly; even a small bar and a bookshelf is visible.

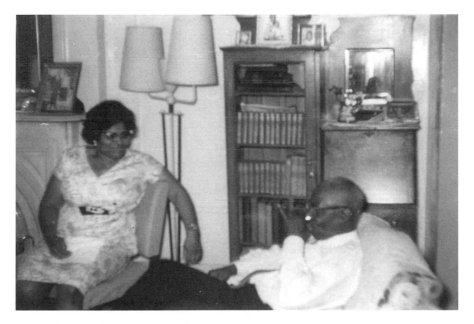

Walter enjoyed a beverage as his cousin watched. The importance of extended family relationships made it possible to survive the transition of migration but also to lay a foundation for future success through hard work and education.

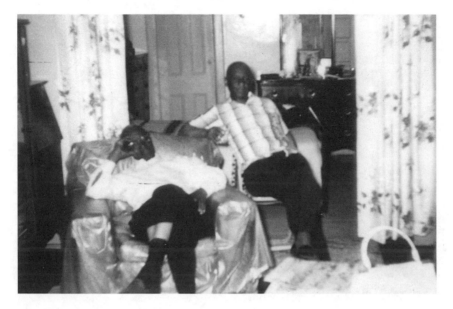

In these images from the post–World War II era, men like Walter and Bill enjoyed the comforts of home in ways that their parents and grandparents could not. The sacrifices of migrating to a northern state where they could own a home, even while working jobs similar to the ones they had in the South, were worthwhile.

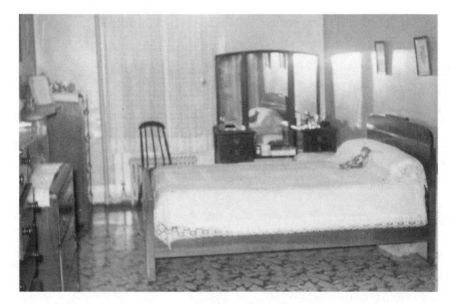

Perhaps this image of Bill Ham's bedroom does not conjure ideas of luxury in the twenty-first century. However, for people accustomed to the deprivation of southern segregation, having a three-part mirror, a full mattress and three dressers of clothing meant a new standard of living that was difficult to imagine just fifty years earlier.

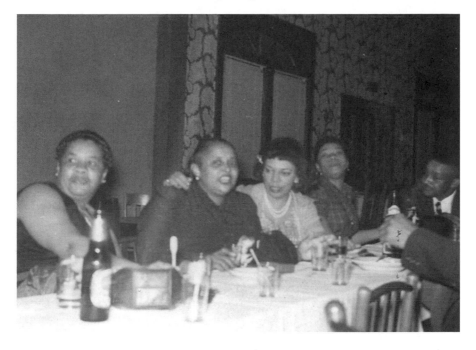

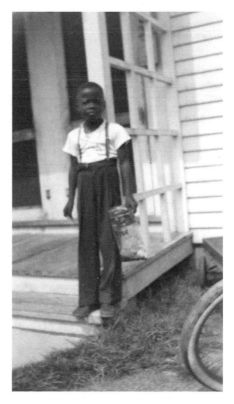

Above: This group of people enjoyed a night of dancing and revelry at the local fraternal lodge. Segregation shaped the recreational opportunities African Americans enjoyed in the United States into the last two decades of the twentieth century. Even after formal Jim Crow signs disappeared from the landscape, social boundaries between people of different races persisted.

Right: This young man stood for a photo on his stoop. His white shirt, dark pants and suspenders marked him as one of the children who helped his parents working on local farms during the growing season. Unlike many of the black children who worked on plantations with their parents as sharecroppers in an earlier generation, he enjoyed better clothing and shoes in addition to exclusive access to a bag of Wise potato chips.

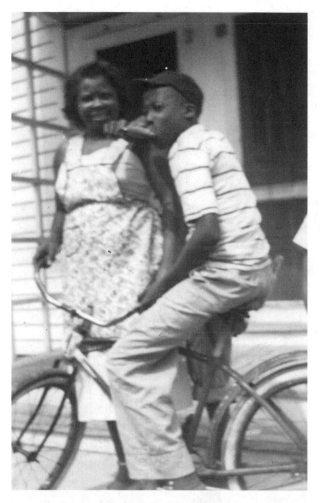

Left: A young man on a bicycle stopped by his neighbor's home in rural New Jersey. Large families provided important support for migrants arriving to the area, but the sense of extended kinship formed networks among many people who were not blood relatives.

Below: Bill Ham and his wife accompanied Marion and her future husband, Wendell, on their first dates. Wendell's mother also accompanied the couple on this particular evening.

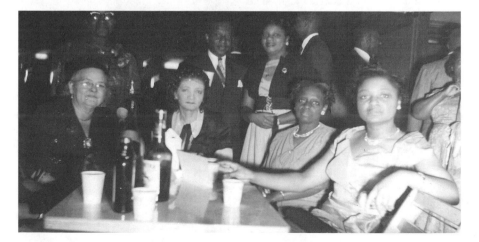

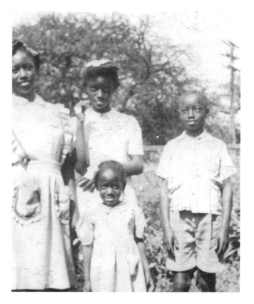

Leona and Wilma Ham posed for this snapshot with two of their cousins. As African American families became more established in small northern communities, the formal portraits of individual family members and children became less common. More accessible photographic technology certainly contributed to this shift. However, the changing social emphasis for families in documenting these memories through photography provided a more intimate insight into the personalities of the subjects.

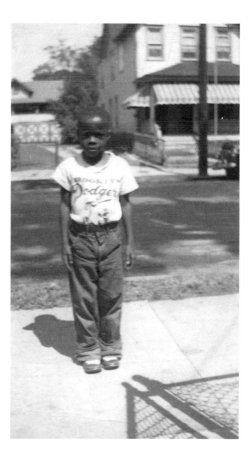

This young man stood on the sidewalk of a fenced yard across the street from a house with both a driveway and a garage. His Brooklyn Dodgers shirt places him in the era of Jackie Robinson's success in Major League baseball. The surrounding community reflects some of the material gains that African Americans made in the wake of that historic barrier of racial segregation falling.

Chapter 2

FAMILY LIFE

As New Jersey's economy became more industrial and less agricultural between 1900 and 1950, African American families relied on the values of interdependence, faith and diligence to defend themselves against prevailing racist judgments. Their efforts to redefine democracy initiated the process of national political reform as immigration dramatically changed the nation's ethnic composition.

Judicial reforms like the *Brown v. Board of Education* decision made the dreams of black children for an equal opportunity more real than their parents could have imagined. Migrant families transformed the horizons of their economic success by moving from the nineteenth-century context of sharecropping to the twentieth-century framework of homeownership, gainful employment and secondary education.

The daily practice of thrift, sacrifice and selfless love taught millions of children the importance of a community beyond their household. The overlapping social contacts between home, church and workplace formed the backbone of the civil rights organizations that would challenge the institutional discrimination against African Americans. Despite the organized resistance of white supremacists throughout the country, the lessons of democratic self-rule began to take hold in state legislatures and political parties. The values of the African American family inexorably changed the culture of the United States.

In the nineteenth century, traveling fairs frequently offered "negro days," when they would be open to African Americans exclusively. This tradition continued through the first half of the twentieth century. For white families,

the slightest contact with African Americans in a context that did not reinforce a sense of racial superiority constituted a threat to the national social order.

Both science and religion agreed that Europeans and Africans were so inherently different that their simple proximity would lead to violence and chaos. One of the greatest threats of industrial urbanization was the possibility that interracial workforces would produce interracial neighborhoods, leading to social contact among children and ultimately miscegenation (biological mixing between different racial populations). White politicians, philosophers and scientists reinforced this paranoia nearly unanimously between 1870 and 1930. African American migrants could not directly uproot these deeply held beliefs in a single generation. Racial segregation at fairs, in schools and in neighborhoods persisted because it rested on decades of racial mythology.

When Bill Ham moved into his first home in the North, it was an apartment in a racially segregated neighborhood. This accomplishment was his first affirmation that moving out of North Carolina was the correct decision. Although the apartment was small by twenty-first-century standards, Bill's pride at the condition and furnishing of the rooms is evident in the sheer number of pictures he took. Friends and family frequently visited and enjoyed meals with Bill and Louise.

Whenever there was a social outing, everyone dressed up and met at the apartment, where Bill took pictures to show how stylish and handsome they were. In his later years, church meetings took place there. The connection between a stable home and the effort to build community through social events and church leadership reflected one of the most important facets of the African American experience in the early twentieth century.

When migrants earned enough to attain a permanent residence, the church communities welcomed them by encouraging their participation in the choir, Sunday school and bible study. Over time, this involvement grew into opportunities for leadership as deacons, trustees and assistant ministers.

George's sense of freedom grew out of the ability to socialize freely and travel. He was a fan of the outdoors. At beaches, in the mountains and touring great cities, George wanted to experience as much of the world as he could. In his childhood, travel beyond his hometown was risky. As African Americans tried to leave the South in the late nineteenth and early twentieth centuries, southern states enacted vagrancy laws that made local travel without written approval from a white authority illegal. Thousands of African Americans were jailed. In some cases, a vagrancy conviction could lead to legalized re-enslavement within the bounds of the Thirteenth Amendment.

Family Life

Among the nearly five thousand African Americans murdered by lynch mobs between 1890 and 1930, approximately one-third of the victims were targeted because they traveled without the permission of a white landowner. The threats to African American life and liberty were real and sustained through the first half of the twentieth century. When someone like George did escape the system of racial peonage, it is a small wonder that enjoying an active social life and freedom of movement would become vital.

The family cookout became one of the first recurring manifestations of how African Americans celebrated their freedom in the North. The small towns in New Jersey often allowed black families to purchase homes as long as they were on streets reserved ("segregated") for African Americans.

A luxury that had been forbidden in much of the South was black landownership. Many of these New Jersey homes had backyards. The yard became a place for the family to gather and share stories about their new lives. The ritual of sharing food with extended family outside of a religious context was a significant advancement in the process of black freedom.

In the eighteenth and nineteenth centuries, it was illegal in most of the United States for free or enslaved African Americans to assemble for any purpose without white supervision. Even where it was not strictly against the law, such gatherings were regarded with extraordinary suspicion. The church was the primary space where African Americans could gather without direct scrutiny for most of those two centuries. Open fellowship among a group of black Americans, even when they were related, on ground that they owned was a radical departure from traditional American culture. These celebrations showed how effective the sacrifices of previous generations were.

When Marion and Wendell purchased their home on Holmes Terrace, they were one of the first African American families to integrate the street. The fact that they were an older couple (in their late thirties) and that they had no children certainly affected the opportunity, even in the early 1950s. Her history in Freehold also provided a greater chance for this achievement. When her parents first moved to Freehold in 1923, she quickly became a babysitter for a prominent, local white family, the Earharts. She cared for their children through her middle school and high school years before briefly attending Wilberforce College in 1932. Her work with the Earharts provided a glimpse at another aspect of family life among African Americans in New Jersey. As day laborers and domestic servants, black migrants relied on middle-class white families to employ them, especially in small towns. In this work, African Americans benefited from a racial paternalism that

encouraged white Americans to care for and to guide those less fortunate than themselves. In resorts like Atlantic City and Asbury Park, these attitudes created white expectations that black Americans offered the best service because it was a racial gift, ordained by God and proven by reason. In villages like Willingboro and Howell, black workers relied on the jobs provided by affluent white families in order to save enough money to secure a stable home and continuing education. As a result, the Earharts viewed Marion as part of the family, and she was invited to their reunions between 1970 and 1990. This personal intimacy between the Earharts and the Hams enabled the second generation of African Americans in Freehold to go to college, to gain professional employment and to achieve a greater share of the American dream than their parents did.

Walter demonstrated the possibility of a more comfortable future in his own lifetime. He and his wife, Lilla, worked more than one hundred hours each week to save enough money to support the ambitions they taught their children. Marion and Kate also worked part time through their childhood to contribute to the family budget. Walter's sons, Walter Jr., Joseph and John, all joined the military to find their path to a better future. The older two served in the Second World War, while John served at the start of the cold war in Germany. As organizations like the NAACP and Urban League successfully pressured the Franklin Roosevelt administration to respond to the needs of African Americans through their support of the Democratic Party in northern states, the opportunities to serve in the military expanded. In 1948, when President Harry Truman desegregated the armed forces, military enlistment became one of the primary avenues for African American social and economic advancement. A generation later, Walter's children had succeeded in securing such a stable lifestyle for themselves and their families that they could take their father on a Caribbean cruise. It was his first excursion since leaving North Carolina fifty years earlier.

All of New Jersey's families embody the history of mobility across regional and national boundaries as well as its political effects. The Ham and Russell narratives connect readers to historic communities. They all valued proximity, autonomy, communication and interdependence. The story of African American life in the North teaches lessons about how competing ideas shaped effective civic engagement. The metropolitan development of the Garden State may still find a way to balance its rural, urban and suburban economies. The unchecked suburban growth of the last two generations did not yield the sustainable lifestyles future families will require

in the twenty-first century. As the United States faces the reality of a diverse world economy for the next one hundred years, families must find new models of sustainable growth. Examining Marion's legacy of community engagement may lead to a more efficient use of a community's resources. Bill's recognition of the balance between work, education and play provides a guide to wellness and success. Walter's examples of religious engagement and educational excellence explain how families can generate a culture that changes their material circumstances. George shows how resilient extended family structures required more social engagement over time. Taken together, these alternative histories address human needs for individuality, family, community and nation in ways that balance and complete each facet of life. How did the lessons of family become the politics of community? African American churches in New Jersey provided one answer.

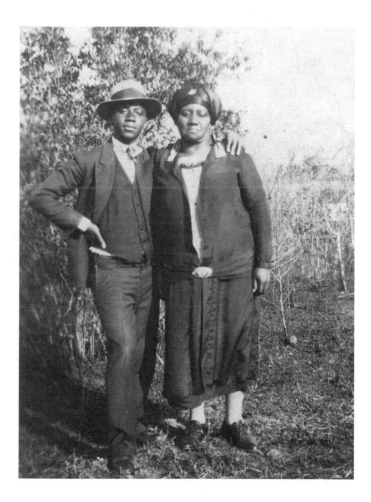

Bill Ham and his mother stood together for this photo in North Carolina.

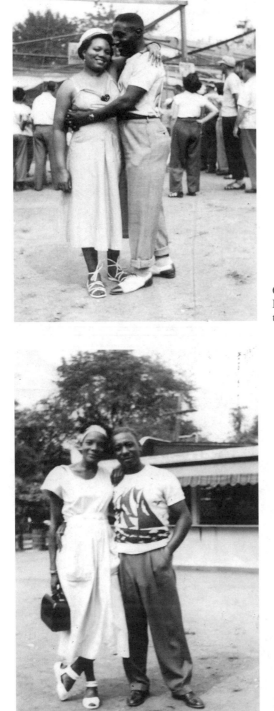

George Ham and his girlfriend, Helen, shared a happy moment at the fair.

Bill and his girlfriend also enjoyed the day.

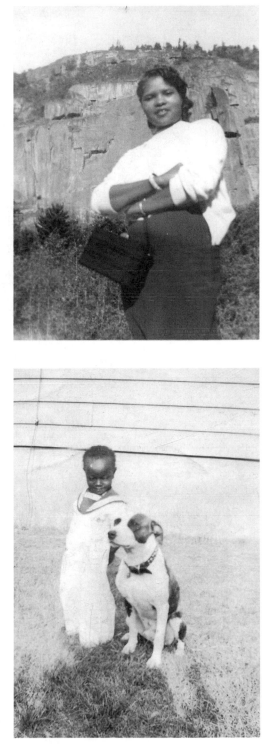

Helen stood at the base of a hillside while she vacationed with George. The low-angle image also established her iconic position in his life.

A classic image of a boy and his dog.

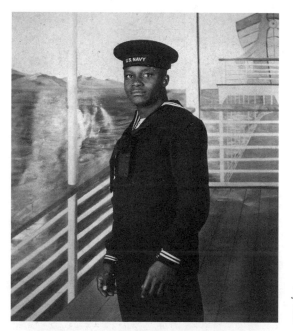

Joseph posed for this formal portrait before going to serve with the United States Navy in 1944.

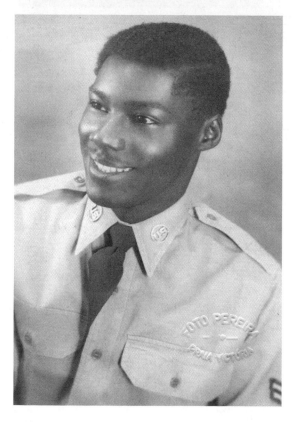

The military remained one of the most reliable paths into the middle class for African Americans between 1950 and 1980.

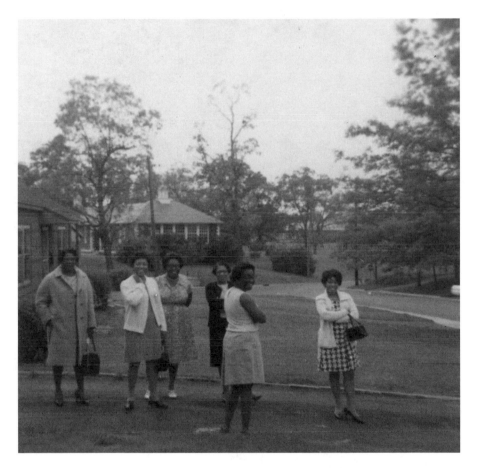

Several of Marion's friends visited her at her new home with Wendell at 4 Holmes Terrace.

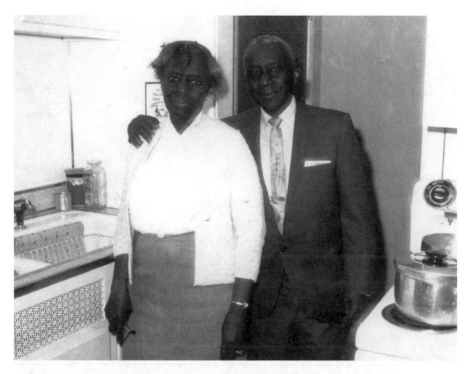

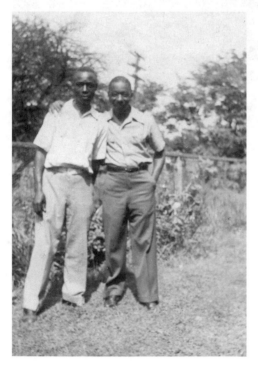

Above: Bill and his mother posed for this snapshot at 4 Holmes Terrace.

Left: Bill and his cousin shared a happy moment in the backyard.

Bill and Walter stopped their conversation for a quick, informal snapshot.

Two of the third-generation daughters waited for the call to attend Sunday services.

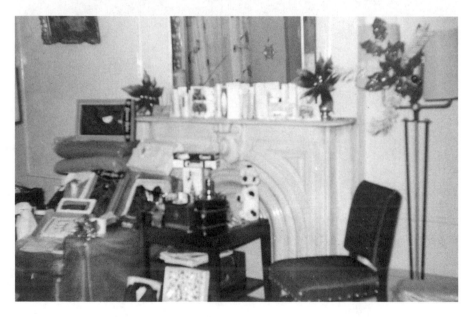

Bill's apartment after a wedding reception.

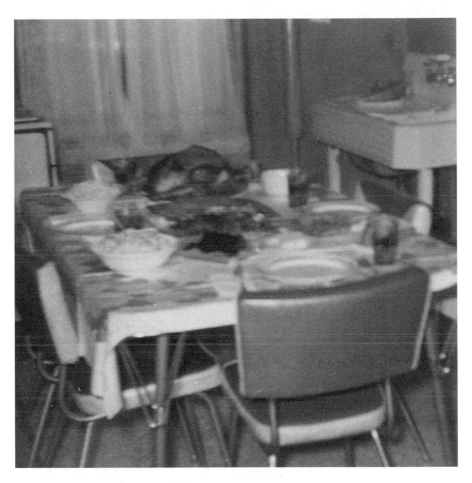

The kitchen in Bill's apartment.

Alternate view of the bedroom in Bill's apartment.

Bill stood among his church's board of trustees in Harlem.

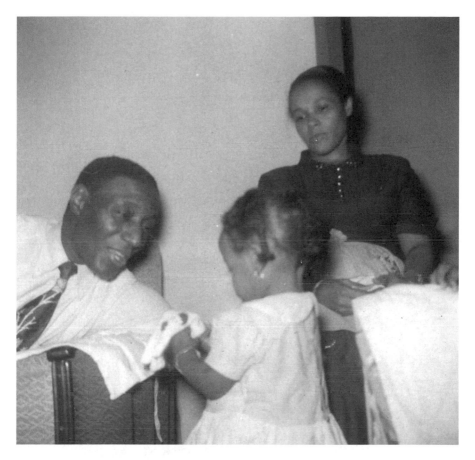

George patiently explained the rules of the house to his niece as her mother watched.

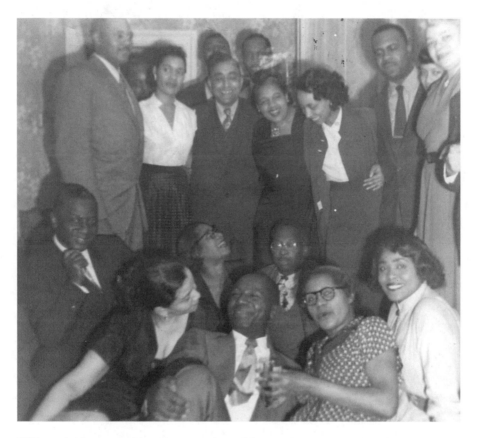

Bill hosted this party at his apartment, where all in attendance apparently enjoyed themselves.

Family Life

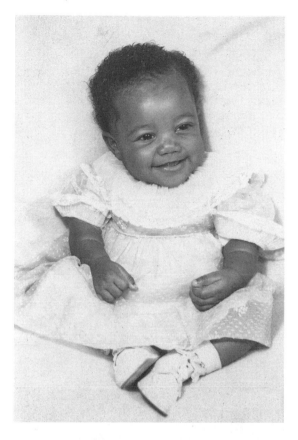

Right: Formal portraits of infants like this one became increasingly common between 1960 and 1990.

Below: Family cookouts like this one were precursors to larger family reunions that became common after 1980.

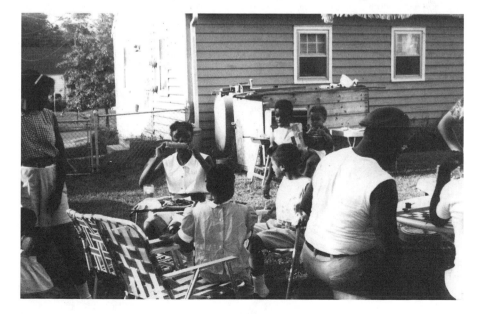

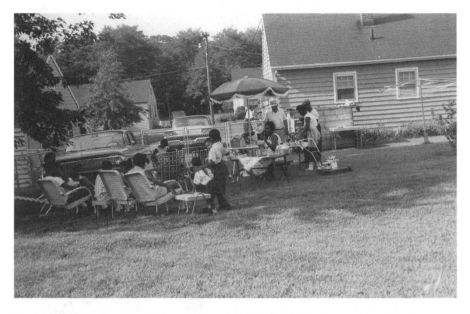

Cookouts with extended family and close friends provided a physical manifestation of the emotional bonds that built and maintained small communities throughout the Garden State.

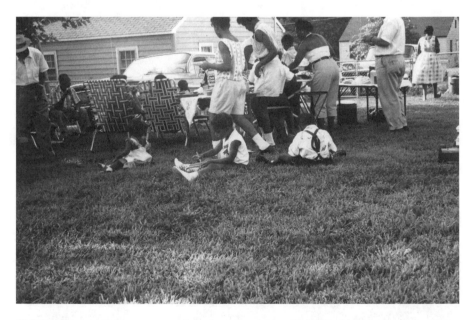

Children were an important part of these celebrations as their lives (and the better quality their parents aspired to) reflected the purpose of moving north and working long hours at difficult jobs.

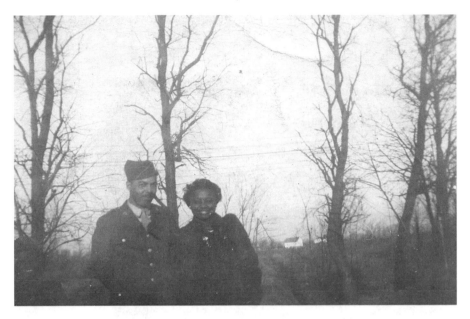

Wendell and Marion still showed their love for each other in this photo after several years of marriage.

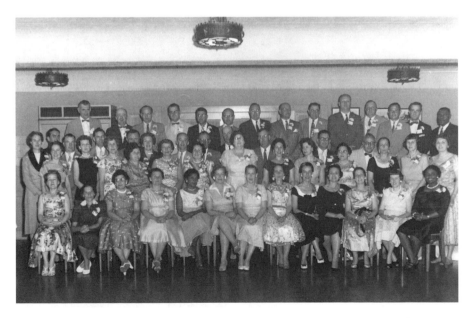

One of the early Earhart reunions established the precedent of inviting Marion Ham Russell to the occasion.

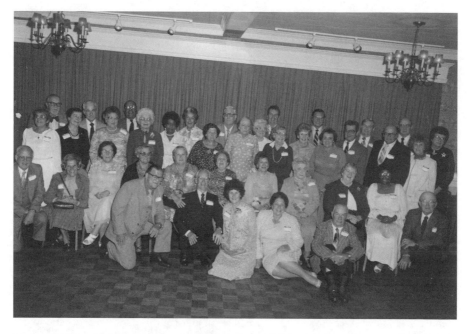

Marion had been a babysitter for the family in her childhood. Interracial reconciliation like this event needed to be more frequent and widespread in the late twentieth century.

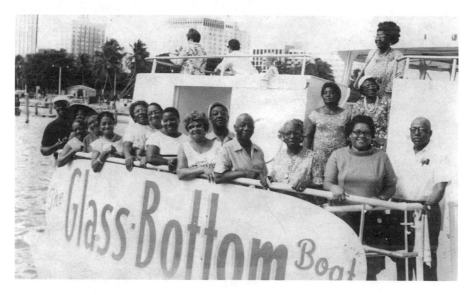

The family enjoys a daylong tour on the glass-bottom boat.

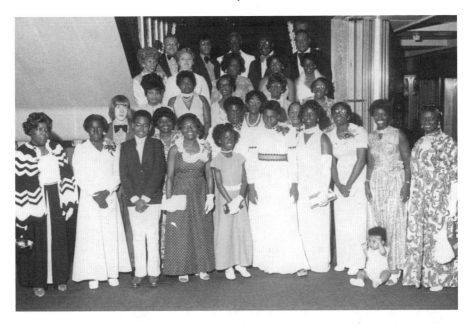

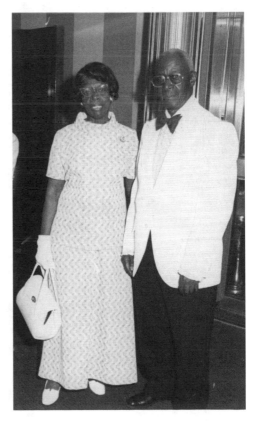

Above: The Ham family cruised in 1974.

Right: Bill and Louise shared a moment on a cruise.

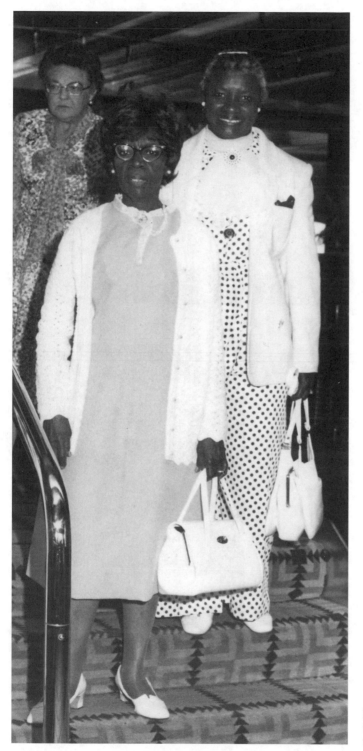

Louise and Lillie took a snapshot on the cruise.

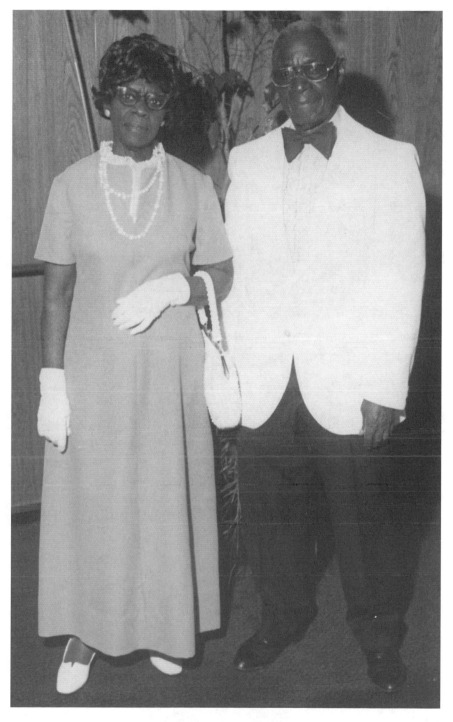

Walter and Louise enjoyed a formal snapshot on their cruise.

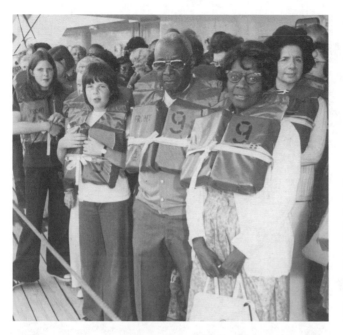

Walter and Louise stood with a crowd during the emergency drill on the cruise. The faces of their fellow travelers reveal the novelty of African American passengers on these luxury getaways even after 1970.

Louise shared this snapshot with her friends, the Bennetts, after church one Sunday.

Chapter 3

CHURCH OCCASIONS

M any Sundays begin with Sunday school for children across the United States. Their voices and laughter open the morning for expressions of faith that rejuvenate millions of people. Families came together throughout the twentieth century in New Jersey to keep the circle of history and fellowship unbroken. The hymns, sermons and prayers created the emotional power needed to create civil rights organizations that could challenge white supremacy. The stories of Exodus, Jonah and Daniel found special voice in the African American tradition. Every congregation learned the lessons of pursuing unlikely success against impossible odds. Church instilled purpose in its members. It provided reasons for continuing the struggle against an unyielding foe.

On Monday mornings, families began their week with the preparation of children for school. Schools formed the center of community pride and optimism, especially within segregated systems in New Jersey. However, the children attended classes whenever possible to fulfill the promise of their parents' sacrifices. In towns as widespread as Gouldtown, Lawnside, Whitesboro, Asbury Park, Freehold and Manalapan, schools reinforced the lessons taught in church on Sunday. Black public schools also inspired academic achievement in communities where messages of racial inferiority bombarded African American children.[3] Churches taught purpose, while schools taught methods. The strategies of civic engagement and the tactics for occupational excellence grew from the instruction of determined parents and instructors who worked in tandem to show young people their visions of a better future.

Together, the function of churches and schools in the black towns of New Jersey during the twentieth century formed the core of the ideological machinery that transformed the United States. This system of racial uplift and social integration created four generations of human beings who disproved the racist sociology, anthropology and history that had passed as scientific knowledge between 1850 and 1950. Ministers, deacons and missionaries shaped community life there, providing regular expressions of autonomy and authority.

Principals, teachers and visiting speakers charted courses toward secondary education, college attendance and professional training that created artists by 1920, engineers by 1950 and corporate executives by 1970. In 1870, the unquestioned seat of public authority was the pulpit. Churches initiated the encounters that defined culture, politics and economics for the small towns in New Jersey. As science and education became the foundation for industrial society in the United States, the racial integration of the state's schools represented the transformation of a racist system. African Americans emphasized the inclusion of their children in school systems as the paramount achievement of their lives.

Richard Allen's African Methodist Episcopal Church created the mold of the church as an institution of liberating African Americans in the late eighteenth century. While Mother Bethel began in Philadelphia, Allen's work spread rapidly into New Jersey after 1800. South Jersey residents Reuben Cuffe and Joseph and Jarena Lee carried Allen's legacy as disciples of the African Methodist Episcopal ministry in the nineteenth century. Mount Zion continued the Methodist connection, while Peter Mott organized the Mount Pisgah society in southern New Jersey.[4]

Racial segregation and discrimination in the early years of the American republic mirrored the divisions of slavery from Georgia to Massachusetts. White churches enforced the recognition of European superiority in every aspect of congregational life. As much as the town hall or the marketplace, churches taught white supremacy throughout the nineteenth century. African Americans in New Jersey seized on the legacy of the African Methodist Episcopal Church in New Jersey to expand Allen's mission to assert the dignity and intellect of black people around the world.

New Jersey's black Baptists did not formally organize until southern migrants began moving north in larger numbers. Baptist congregations did not create hierarchies like the Methodists but instead functioned very independently of one another. Without a larger organizational structure, Baptist communities grew more slowly than the Methodist churches did.

Once a Baptist church opened in a town, however, two or three additional places of worship often followed.

Baptist churches were the founding institutions of several new black communities. In Glassboro and Mullica Hill, there were nine Baptist churches by the start of the twentieth century. Conflicts among the Baptists revolved around theological issues, creating some confusion about the future of these African American communities. In 1908, a group of ministers established the Bethany Baptist Association of Southern New Jersey and elected Reverend J.T. Plenty of Kaighn Avenue Baptist as the first moderator.[5] This consolidation signified the establishment of two major African American theological traditions among the small towns of rural New Jersey.

Much of the fundamental, doctrinal debate within the Methodist and Baptist traditions in New Jersey resolved itself through the first two decades of the twentieth century.[6] As the small towns grew, disagreements over church leadership and social programming became more common. The Holy Trinity formed the core of the African American community's spiritual life, guiding early black migrants through the difficult transitions in residence, work and recreation in a new setting.

The collision between the social customs of the rural South, the urban North and the rural North produced some of the most emphatic debates about the formation of an African American cultural identity. Conversations about the proper reference title for former slaves and their children often reflected profound and complex arguments about the future of American freedom. Choosing a description ("colored," "negro" or "Afro-American") signified an ideology about the purpose of achieving full citizenship rights. Language dictated the creation of new spaces (black churches) and the social meanings communicated there (family, history and leadership).

New Jersey's rural black churches existed at the intersection of faith and reason between 1870 and 1920. The creation and survival of small African American communities relied on the ability of the church to maintain a sense of community for new residents. These institutions brought the ideas and theory of divine will into the realm of material debate about homes, jobs and education. Sharecroppers questioned attorneys, and nursemaids interrogated pastors. Accountability was the currency of the society, as everyone knew the stakes of success or failure were high.

Church leaders articulated a vocabulary of faith to sustain families against poverty and unemployment. They used scripture to offer a body of values that opened new opportunities for reason to the congregation as a whole. Within the context of New Jersey's de facto racial segregation, black churches

formed centers for both worship and recreation. They allowed mental peace and intellectual creativity in a society that permitted neither. When Leona Ham and Obadiah Brown married at Bethel AME Church in Freehold, it was a major event. The survival and success of black migrant families in their attempts to find work, to acquire better homes and to secure more education yielded a new platform for the dreams of the next generation.

Churches established the foundation of black communities in the late nineteenth century. New Jersey's small towns changed politically, culturally and economically as a result of their presence. The challenge to racial segregation in the state's school system rose from these small towns as reason and faith intersected in the activism of the black church. Heroes, including the Ham brothers and their children, pursued the accomplishment of racial equality in the twentieth century with single-minded devotion. Civil rights organizations formed a system of public accountability that transformed the United States in the second half of the twentieth century as a result of their collective efforts. Against prevailing notions of black inferiority, New Jersey's black churches and schools taught pride and dignity in ways that redeemed the promise of America. A new standard of leadership and organization united religious and educational leaders in this project. Civil rights ceased to be the radical cry of abolitionists of the late nineteenth century and became the core principle of democracy at the start of the twenty-first century.

African Americans created the network of churches and schools in these communities from nothing but their determination and creativity. The discussions about the nature of black identity and the balance between religious and educational institutions were often difficult for the diverse migrants who came together for the first time in the early decades of the Great Migration. Their sense of shared sacrifice and painful memories of the oppression they faced provided a common commitment to survive whatever adversity surfaced. Their love for the children and hope for a brighter future shaped the opportunities for higher education and better jobs that these communities enjoyed at the heights of the civil rights movement. Groups like the NAACP and Urban League only developed their agenda and support based on the connections forged by the churches and schools in the first half of the twentieth century. Their organizational success created the greatest transformation of American democracy in the nation's history by 1970.

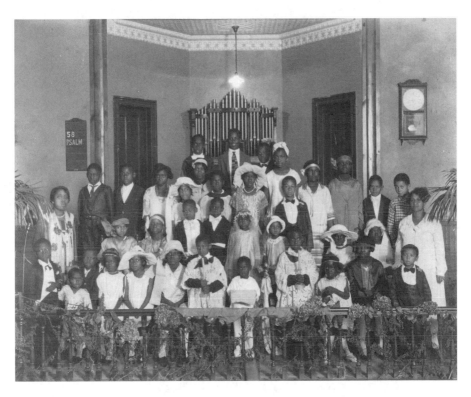

The image of a large youth choir in Bethel AME Church demonstrates the vitality of these institutions in New Jersey's small towns in the first half of the twentieth century. From toddlers in the front row to teenagers in the back, their posture and clothing reveal the discipline and self-esteem that the church community taught.

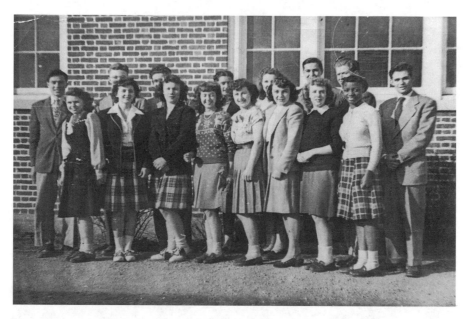

Lillie Ham was the only African American member of her high school class in 1947. Pioneering black students like those in the Ham family built on the legacy of their parents' work as domestic servants to craft an image of educated, skilled African American workers who became the heart of the black middle class in small towns after 1950.

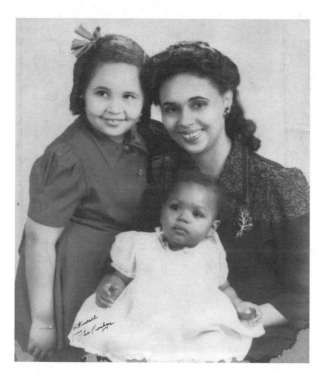

Wendell's sister and her children provide evidence of the ways cultural values like femininity and womanhood affected generations of African American families. Combining the dignity and integrity of her parents' generation's family portraits with the assertiveness and comfort of her generation revealed the evolution of the African American experience between 1900 and 1950.

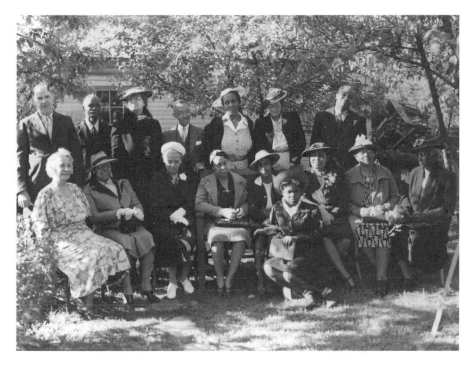

Above: Mother Russell's church choir illustrated the function of church community as both extended family and social authority. The style of hats, dresses and suits all present complicated codes of respect and acceptance, as did the positions of the people in the photograph.

Right: Leona Ham sat with her husband, Obadiah Brown, and her parents, Walter and Lilla Ham, at her wedding. Bigger ceremonies for major life events were a part of life that the older generation could not afford in most cases.

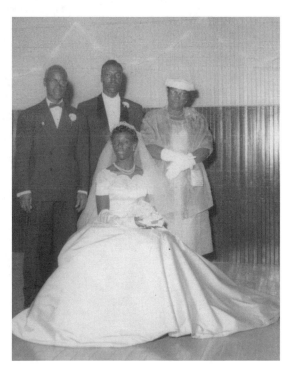

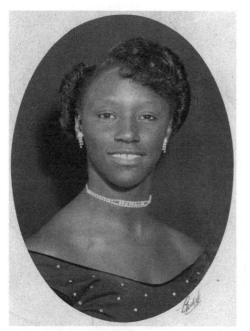

Left: Leona's graduation photo showed one small way African Americans began to be included in the standard rites of passage for all teenagers as they gained access to secondary education after 1940.

Below: Leona and Obadiah cut their wedding cake.

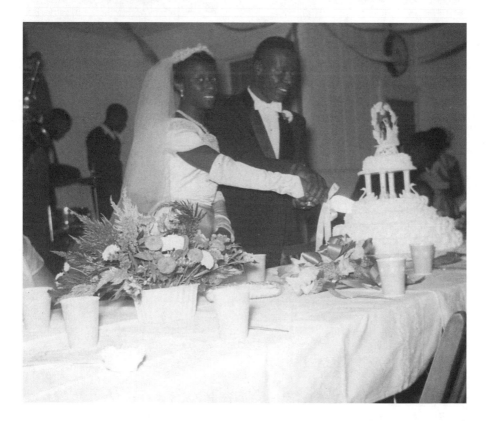

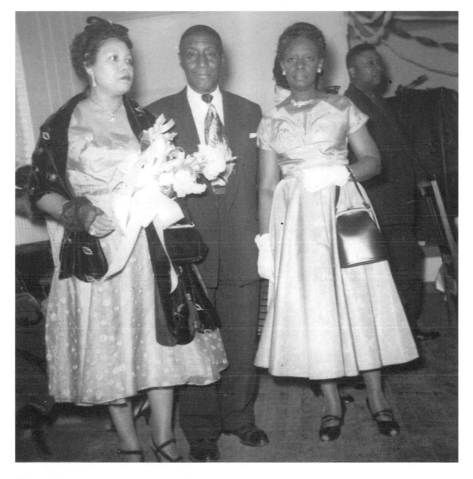

Helen, George and Louise at Leona's wedding.

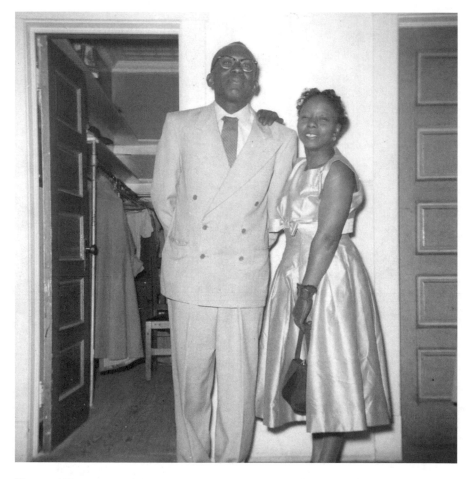

Kate and Themer posed for a snapshot. Their pride at this occasion shines through the years that have passed.

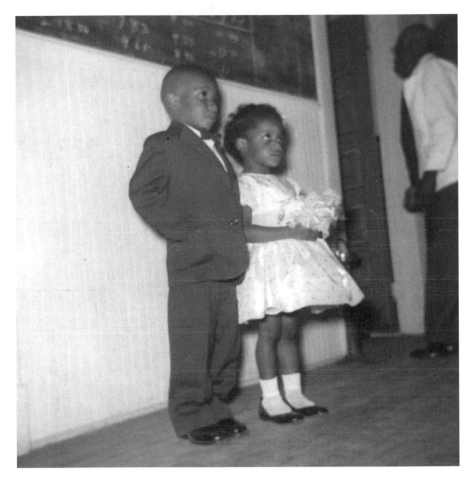

Ring bearers and flower girls represented an important way that the formal expectations of family events were communicated from one generation to the next.

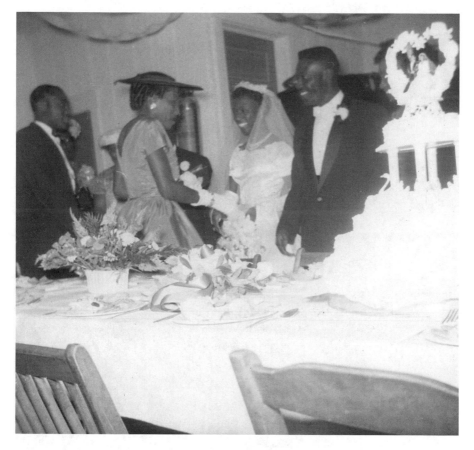

Ella Brown, the mother of the groom, greeted the newlyweds before they sat down and enjoyed the wedding cake.

Church Occasions

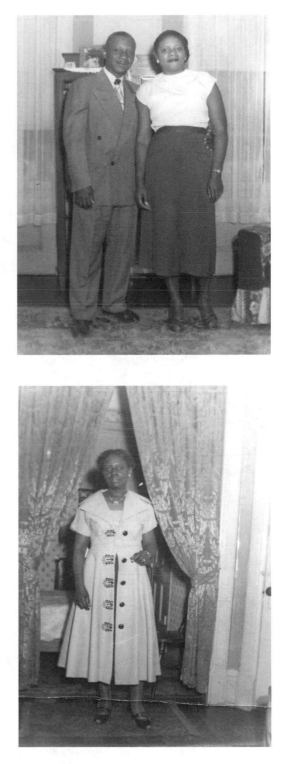

Bill and Helen smiled for this
snapshot before the ceremony.

Louise posed for this snapshot in
Bill's apartment.

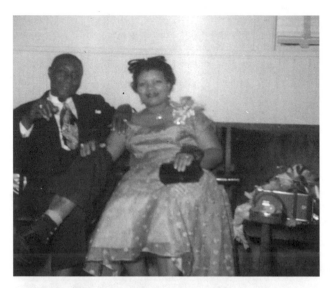

George and Helen enjoyed a quiet moment after the wedding at the back of the sanctuary.

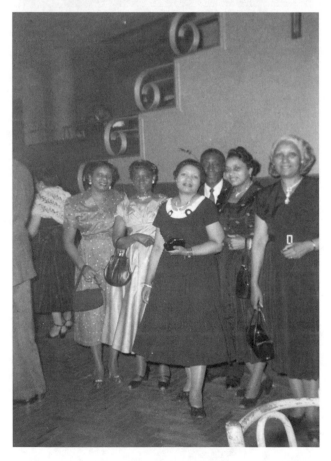

George, Helen, Louise and their friends shared a moment at the start of the wedding reception.

Church Occasions

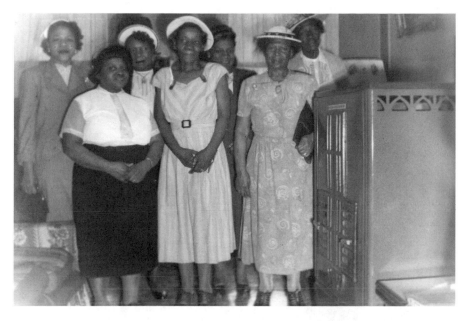

The Women's Auxiliary of the church gathered for a photo at Bill's apartment.

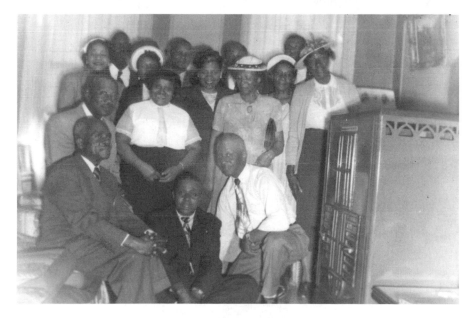

Bill and the other trustees of the church joined in this snapshot, much to the happiness of the Women's Auxiliary members. In the foreground, one member still remembered to adopt the nineteenth-century posture of looking away from the camera to provide a dignified profile image.

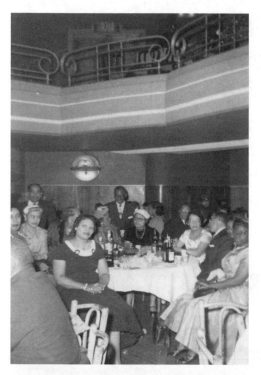

Helen smiled for George in this photo as many of the other reception attendees missed the opportunity. Bill caught the chance in the background.

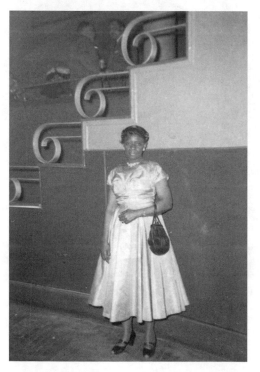

Louise posed for this snapshot at the start of the reception.

Church Occasions

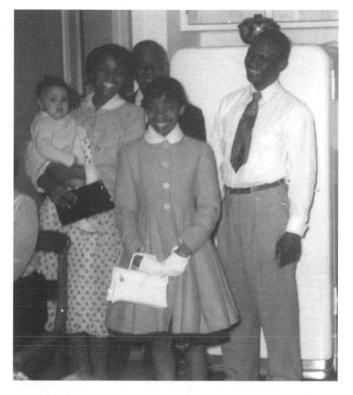

Bill and Walter's son, Joseph, enjoyed the company of a few grandchildren at 125 Court Street. In the last decades of the twentieth century, these kinds of informal photographs of multiple generations of a family became more common among African Americans in New Jersey.

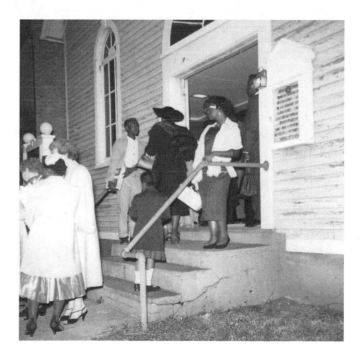

Church services ended at Bethel AME Church in Freehold. African American churches like this one were the foundation for black survival in the United States during slavery and segregation.

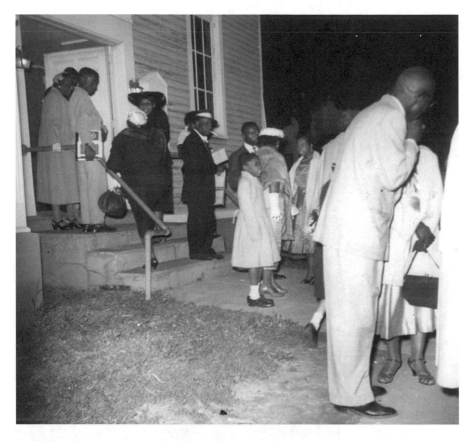

Here is another view of the congregants after services. In small communities, churches like Bethel AME provided literacy support for children and adults as well as served as a network for job opportunities and informal unemployment insurance for migrant laborer households.

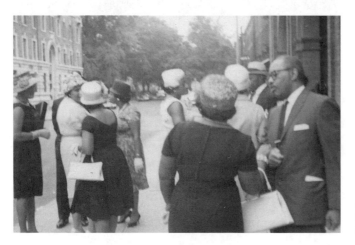

A crowd enjoyed the social occasion after church service.

Bill, Walter Jr., Louise and several of their nieces and nephews appear in this candid snapshot.

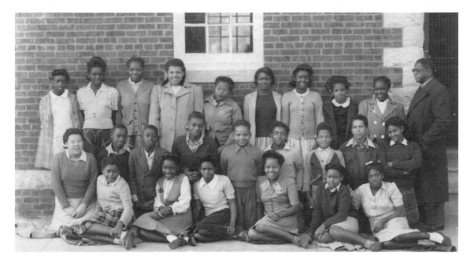

Wilma Ham's class at Court Street School in 1945. Segregated schools in New Jersey relied on the local churches for both staff and financial support. The values offered on Sunday mornings were often reinforced on a daily basis during the week as deacons and choir members became principals and classroom teachers.

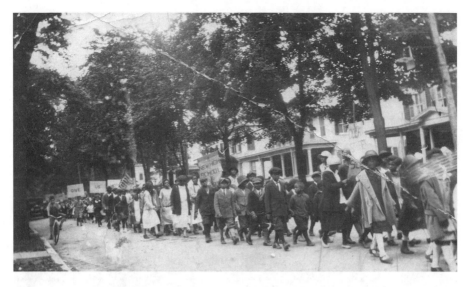

African Americans protested the conditions of segregated facilities like Court Street School for nearly a decade before the *Brown v. Board of Education* decision.

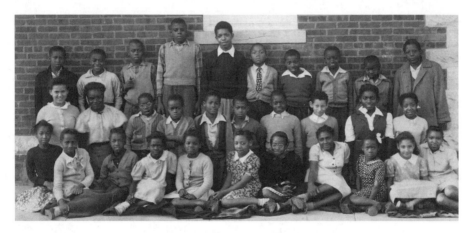

John Ham's elementary school class at Court Street School in 1945.

Chapter 4

FREE AT LAST

Joyful expression has its deepest roots in human dignity. A person can be dignified without being joyful, but the presence of joy requires some degree of self-esteem. Extraordinary happiness originates in a profound sense of self-worth. This relationship is the reason why many young adults have pushed for change throughout the twentieth century. Their vigor springs from the conviction that their beliefs have worth and deserve recognition. African American young people in New Jersey channeled their dignity into the pursuit of excellence. They proclaimed their humanity against the public presumption of their inferiority. Their work shaped dozens of communities during the first three decades of the twentieth century.

Parents, teachers, ministers and local authorities all struggled to manage public challenges to white authority among the black youth by counseling caution. These leaders tried to teach them their "rightful place" in a society that preferred whiteness as the standard of excellence and acceptance. Where the church taught them to survive and the school taught them to succeed, the generations of African Americans who came of age after 1930 increasingly refused to accept second-best as any part of their lives.

Politics became the arena where the children could advance their dreams of equality. Where the schools and churches failed to challenge the boundaries of northern segregation, young African Americans claimed the mantle of the "New Negro" and asserted their rights to justice and fair treatment.

Negotiations with white elected officials rarely produced changes in anti-discrimination law or corporate policies restricting black access between 1900 and 1930. Lawsuits and protests held white authorities accountable for

the violation of civil rights in the small towns across the state between 1930 and 1990. Sixty years of steady challenges to each form of discrimination and segregation tested the mettle of both the activists and the authorities who opposed them.

In the first two decades of the twentieth century, defeats outnumbered the victories for black advocates. However, as black electoral power forced white legislators to acquiesce at the state level after 1945, the tide began to turn. A full generation after African Americans in New Jersey organized chapters of the NAACP throughout the state, legislative breakthroughs became more common, and private entrepreneurs abandoned the informal enforcement of racial restrictions in their restaurants, hotels and stores.

The *Pittsburgh Courier*'s national "Double V" campaign catalyzed much of the energy within the black community during the Second World War.[7] Victories against Nazism abroad and racism at home provided a public framework for African Americans to challenge the social assumptions about their status and heritage.

Newspapers like the *Afro-American* conveyed the campaign for black patriotism and civil rights to dozens of small communities throughout New Jersey. Brief reports updated the activities that churches, schools and civil rights organizations undertook to support the international efforts to hold the United States accountable to its rhetoric of human equality.

Militant expressions of black pride became common for the first time in the state's history. New Jersey's Fair Employment Practice Law of 1945, Civil Rights Act of 1949 and creation of the Division against Discrimination in the Department of Education opened the door for aggressive African American leadership within the state government. Over the next decade, a surge of black political involvement transformed urban areas like Newark, Trenton, Camden and Atlantic City.[8] Small towns, however, remained a bastion of resistance against these changes for the remainder of the twentieth century. White leaders in small communities held fast to the traditional beliefs that white supremacy possessed divine sanction, requiring the subordination of African Americans for a functional society.

The inheritors of the legacy of white supremacy did not simply surrender and take up the banner of black equality after 1970. For the next three decades, legal battles continued to define the limits of human equality within the law. One of the most profound changes was the criminalization of civil rights protest. Law enforcement officials developed strategies to marginalize and silence civil rights activists without using mass arrests or state violence to suppress demonstrators. Media outlets that provided

sympathetic coverage to ministers and their congregations before 1970 increasingly ignored their actions or relied on police accounts of their activities between 1980 and 2000.

After the election of Ronald Reagan, conformity became a measure of patriotism. African American images on television, in movies and in music rarely echoed the sounds and images that shaped the civil rights era. White Americans cared less about the substance of black cries of protest, spurning instead the mere whisper of it. The joy of a generation inspired by civil rights victories between 1940 and 1970 withered behind prison walls.

One of the hallmarks of this rejection of civil rights groups was the assertion that colorblindness was the standard Martin Luther King Jr. championed in his speech at the Lincoln Memorial in August 1963. Willfully mistaking literal reading for symbolic meaning, King's opponents seduced the innocent to believe that any discussion of race was itself racist.

Even as the racial wealth disparities widened between 1980 and 2000, many Americans believed that African Americans no longer faced any form of racism in their neighborhoods, homes, schools, jobs or banks. The legal success in dismantling overt racism in the form of Jim Crow segregation enabled black families to gain a stronger grasp on their American dreams. In New Jersey and across the United States, African Americans enjoyed access to college education, protections of workplace discrimination and levels of political representation that were unparalleled in American history.

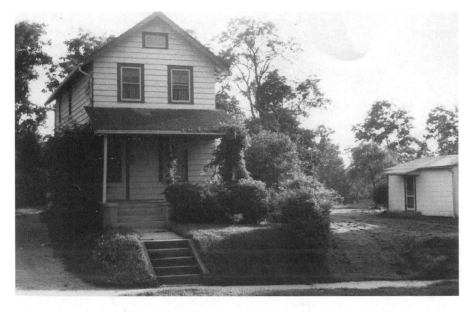

The two-tier, A-frame home was the dream house of many African American migrants in the first half of the twentieth century. Leaving southern towns where sharecroppers' homes might only have one or two rooms with an outhouse, the possibility of having a multiple-bedroom home with a driveway and a storage shed appeared luxurious.

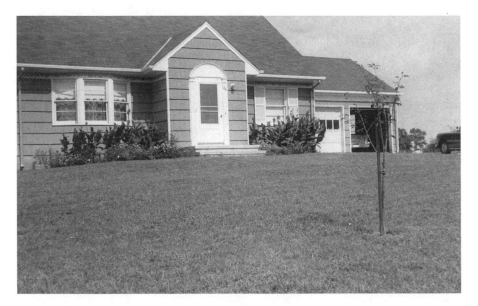

Walter and Lilla purchased their dream home just before the passage of the laws that ended Jim Crow segregation throughout the United States. With a driveway, a two-car garage, large front and backyards and three bedrooms and two bathrooms, they finally had their piece of the American dream.

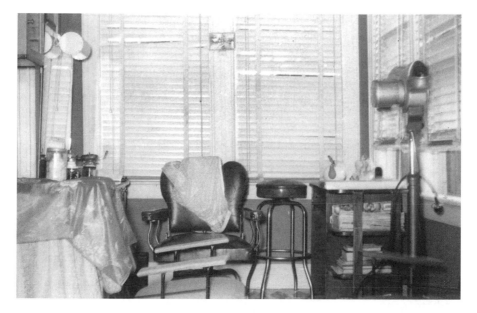

Above: Bill Ham's bathroom was a significant improvement over the outhouses used by many rural black families in New Jersey before 1930. The space, storage, comfort and privacy all marked the improving social status for African American families that could secure them.

Right: Wendell Russell stood outside his family home for this snapshot. The casual nature of the image and his comfort contrasted sharply with earlier photos from his childhood and his work photographs. In this setting, Russell still shows confidence, but there is a warm, welcoming posture and expression that reveals the informality and comfort of the scene.

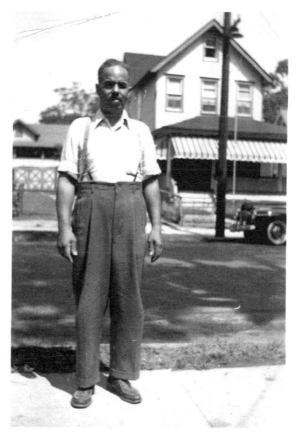

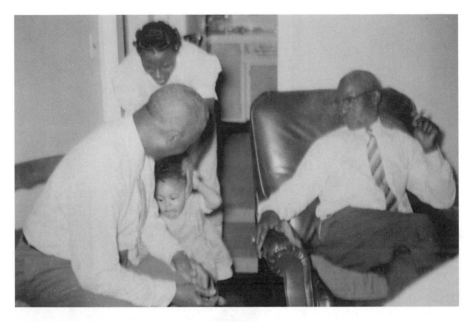

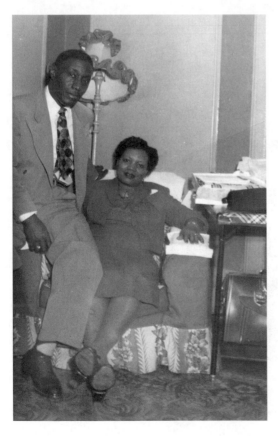

Above: Walter and Bill Ham observed Lillie as she supported her niece's first steps into the family living room. The multigenerational nature of African American families in rural communities gave personal support to an older generation while providing emotional and financial support for the younger adults in the family.

Left: George and his girlfriend, Helen, enjoyed a quiet moment at Bill's house.

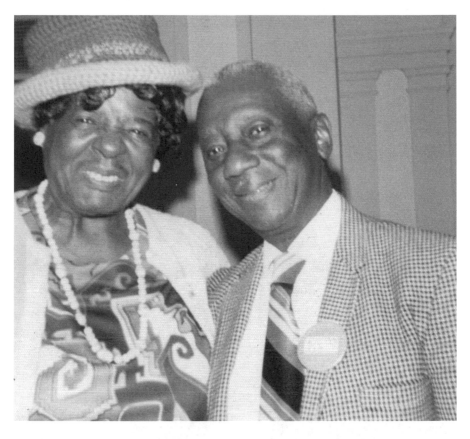

Above: Bill and his aunt shared a funny moment together. The intimacy of these snapshots communicates the value the subjects and the photographers placed on documenting generational connections. In a society where their family bond was not legally recognized just two generations earlier, the celebration of family love was paramount.

Right: George posed by the television in his best church suit.

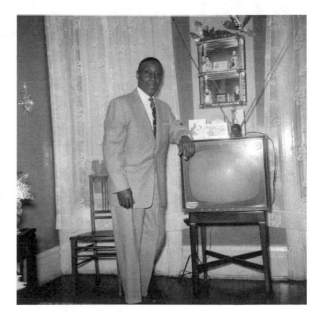

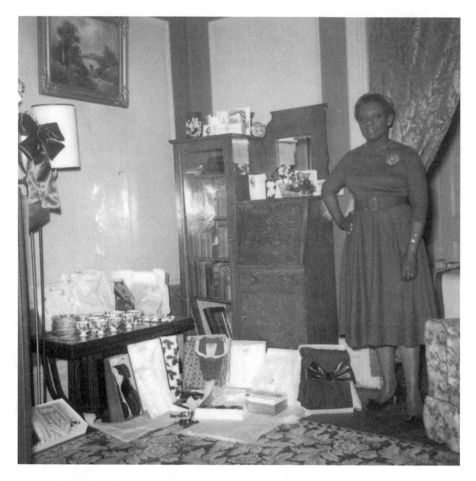

Louise also posed with the gifts the couple received from the wedding reception.

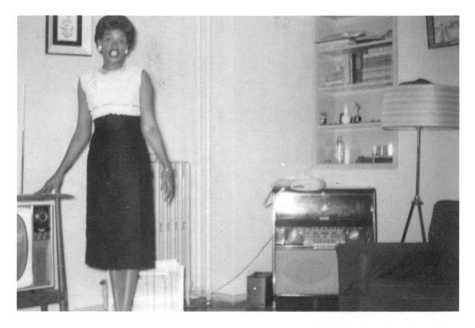

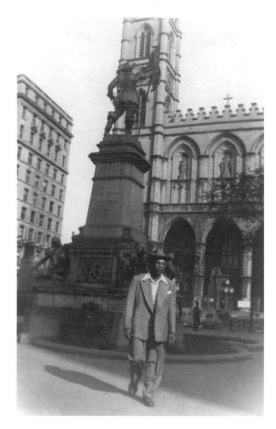

Above: One of Bill's friends got caught unprepared in this snapshot, but the way the television, radio, lamp and chair are featured show how he demonstrated his entry into the American middle class.

Right: George walked behind the Cathedral of Notre Dame in Old Montreal.

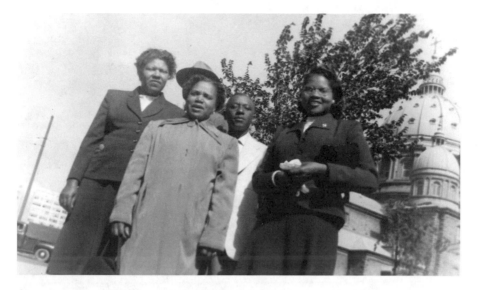

Above: The Ham family took this snapshot near the Cathedral of Mary, Queen of the World in Montreal on their vacation. The low angle makes them appear almost as monumental as the building.

Left: Helen rested her feet on the steps behind the Cathedral of Mary. Canada held a special significance for African Americans during segregation that stretched back to the nineteenth-century history of American slavery. The Canadian border represented freedom not only from the plantation but also from the reach of slave catchers who operated under the sanction of American federal law between 1790 and 1864.

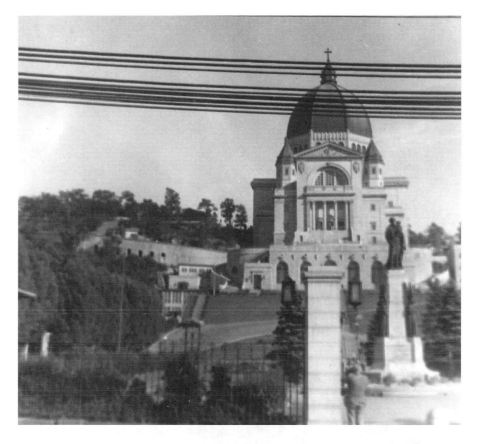

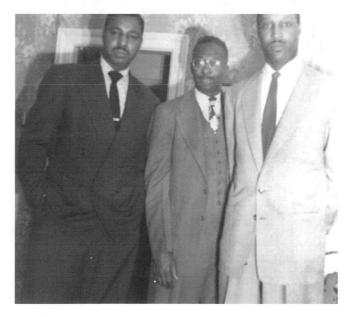

Above: St. Joseph's Oratory in Montreal, Quebec.

Right: Three men gathered at the Ham apartment before an evening out on the town.

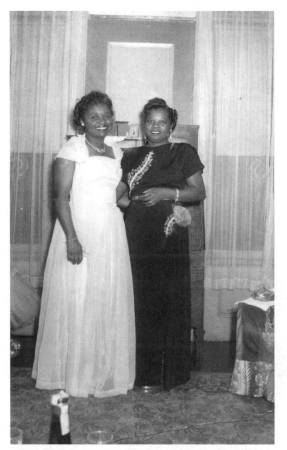

Left: Marion and Celia smiled for this snapshot at Bill's apartment before an evening out in New York City.

Below: Bill playfully carried his friends in this wagon on their vacation.

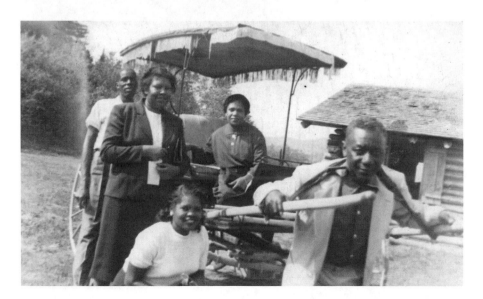

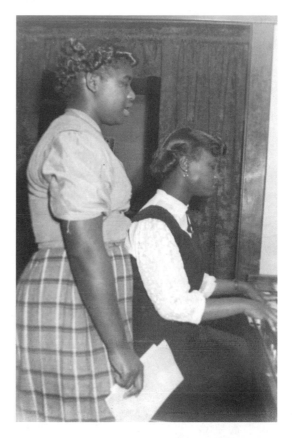

Right: Walter's daughter, Wilma, taught a student the piano. Musical instruction was a common part of middle-class aspirations among African Americans in New Jersey.

Below: Celia smiled for this snapshot in Walter Jr.'s apartment. The photo of Walter Sr. and Lilla on the mantel emphasized the importance of family memory through photography.

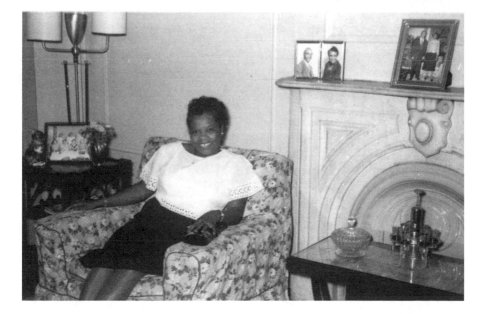

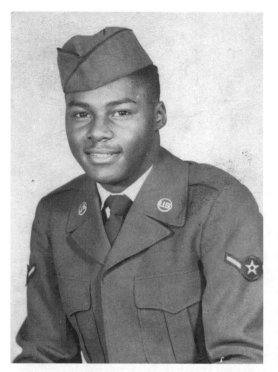

The Second World War was a major turning point for African American involvement in the military. For many of the most talented and educated African Americans, service in the Armed Forces was the only path to white-collar employment, college education and homeownership between 1940 and 1980.

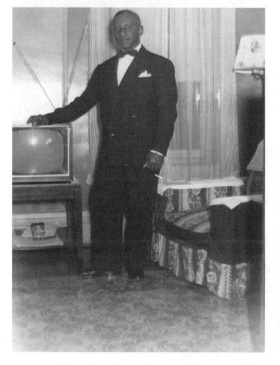

Bill dressed up well for an evening out with his wife. Posing by the television was frequently a measure of status among black families. The emergence of the television as a status symbol after 1950 occurred alongside the development of the civil rights movement. In many ways, the transformation of the United States into a more racially just society would have been impossible without broadcast television.

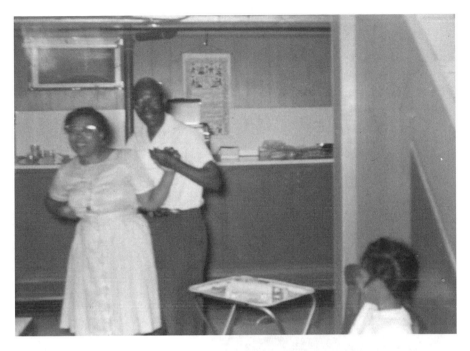

Above: Walter and his wife, Lilla, playfully danced in the basement of their dream home as one of their children watched.

Right: One of the measures of full inclusion for African Americans in American society was the ability of black teenagers to attend high school proms. Here, Donna Ham and her date represent the second generation of black students to enjoy the same rights and privileges as their white counterparts after 1975.

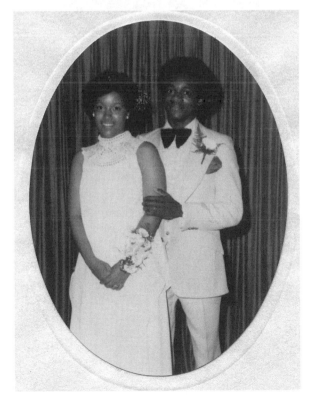

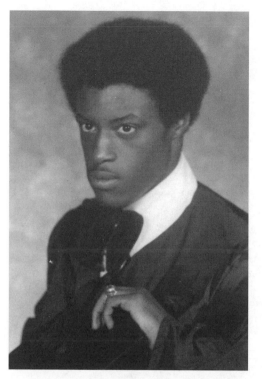

Toran, Obadiah and Leona's oldest
child, graduated from high school.
He represented the second generation
of African Americans to complete
secondary school in small towns across
New Jersey in the twentieth century.

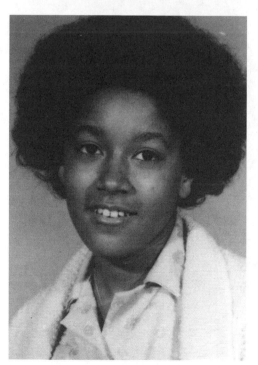

John's daughter, Donna, was another
member (along with Toran) of
the second generation of African
Americans to complete high school.

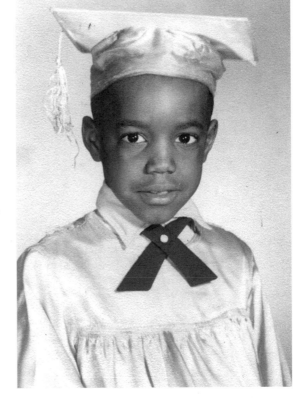

Right: As educational achievement became more available to African Americans after 1950, graduation ceremonies and attire for younger children became more common.

Below: This family portrait represents a significant shift away from the formality of similar images earlier in the twentieth century. The availability of cheaper technology made informal snapshots of families increasingly common after 1960 in northern black communities.

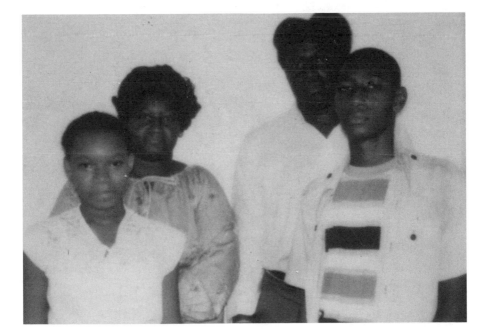

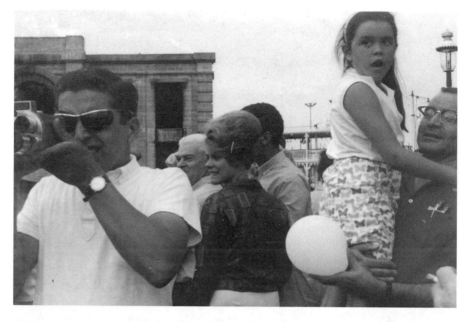

This informal group photograph from the Jersey shore revealed Marion's acceptance in an integrated setting after 1960. New Jersey's beach resorts persisted in the maintenance of unspoken racial segregation into the years that followed the Second World War.

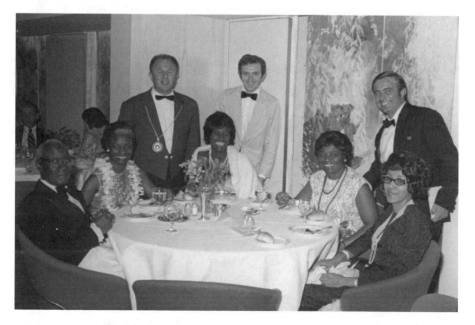

At the start of the twentieth century, this image could not have existed. Four black women and an older black man could not dream of being seated on a cruise ship as they received service from three white waiters.

Chapter 5

FIRST PROFESSIONALS

The educational and economic aspirations of African Americans nationwide transformed the expansion of the black middle class in the United States in the second half of the twentieth century. In 1800, few free blacks could expect equal compensation for the same work that a white person completed. Most white Americans believed that the idea of black education was dubious at best. One hundred and fifty years later, New Jersey redefined democracy by fully enfranchising the descendants of former slaves. The state would no longer accept the assertion that racial categories should delineate the boundaries on African American social status.

As racial limitations became financial qualifications, black families changed the ways they interpreted the meaning of equality after 1950. Where income, occupation and education held significance *among* African Americans during the era of northern Jim Crow, net worth (especially homeownership) and conspicuous consumption emerged as the keystones to black respectability in New Jersey by 2000.

Several ideas for the continuation of racial uplift in economic terms emerged after 1970. The spectrum ranged from advocates for black capitalism to supporters of black socialism. Civil rights laws provided a framework for legal challenges against overt segregation and discrimination between 1965 and 2000. However, widespread poverty, unemployment and crime increased in many African American neighborhoods in both the Garden State and nationwide.[9] Rates of black homeownership and new business creation fell in the two decades following the Civil Rights Act of 1965, despite the debates and proposals for economic empowerment.[10]

Some leaders emphasized the need for African Americans to participate in the market economy.[11] Other analysts asserted that private racism continued to frustrate economic development in predominantly black cities and towns.[12]

African Americans were more socially integrated than ever as consumers, and this trend manifested in the expanded opportunities for travel and tourism many families enjoyed.

Consumerism emerged as a major force in African American households in the United States after 1950. Community investment had guided much of the spending of the black professional class in earlier generations. African Americans often used their dollars to support projects to transform the life opportunities of their neighbors and children, despite prevailing racial segregation.

A different pattern took shape during political integration between 1950 and 2000. Individual spending shaped the American dream for the generations that benefited most from the civil rights laws. If you spend enough money on the popular consumer goods, everyone could be part of the middle class.

Mass media in the shape of radio, film, television and the Internet promised an infinite supply of consumer goods to anyone who watched or listened. This transformation of New Jersey's villages into commuter suburbs contributed to the globalization of the world economy at the end of the twentieth century. African Americans simultaneously experienced access to homes, cars and technology they could barely afford a generation earlier, while abandoning some of the crucial habits of thrift and careful planning that had created their prosperity initially.

African American families in New Jersey at the start of the twenty-first century reflected much of the social context that characterized the entire nation at the time.[13] Popular movies and television shows oversimplified answers to complicated social questions. Falling into paradigms of a "class-less" nation and individual meritocracy, middle-class African Americans in New Jersey's small towns stopped organizing groups for social change. Buying the newest television, computer or cell phone became the focus of personal freedom for many young people of all races.

Sustained investment in community organizations appeared old-fashioned and out-of-date. The abolition of legal segregation failed to achieve the dream of racial integration as the black middle class decided that style was preferable to their parents' and grandparents' lives of patient sacrifice. Bill, George and Walter Ham used every resource at their disposal to pursue a

better future where their children could overcome white supremacy. Without the same commitment to community investment at the end of the twentieth century, black Americans became part of the consumer middle class.

African Americans in New Jersey have the opportunity to reverse this trend. Martin Luther King Jr. said in 1967, "We as a nation must undergo a radical revolution of values."[14] He spoke directly to the crisis of global materialism. Corporations needed to adopt the principles and values of the civil rights movement to develop a more civilized world.

The ideas about the fundamental human dignity of all people transformed America. Small towns remained the bellwether of social change in the United States and around the world. Black families carry a tradition of developing and maintaining community that can instruct all people about the value of democracy in the twenty-first century.

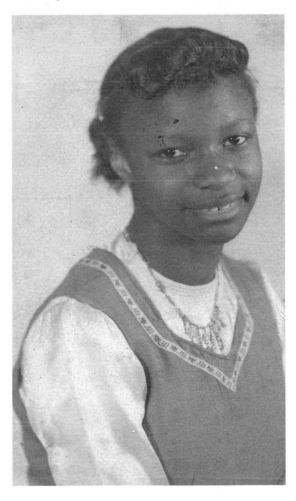

Lillie sat for her middle-school graduation photo. Leaving the Court Street School for an integrated high school was the start of an extraordinary career in education.

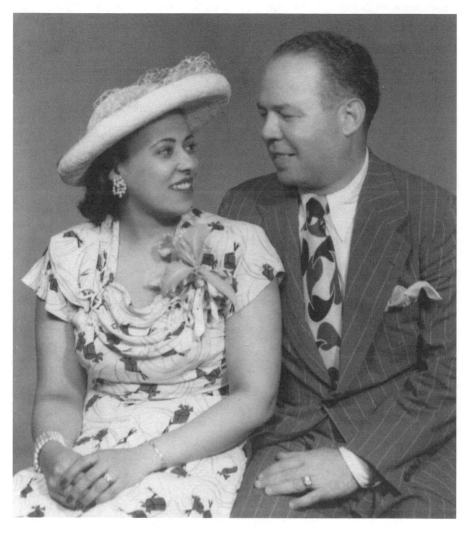

Wendell's brother and his brother's wife sat for this loving formal portrait after their wedding.

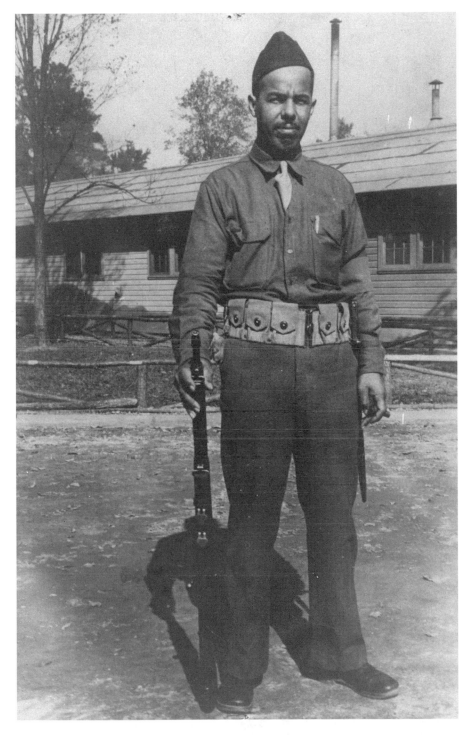

Wendell became part of the military police at Fort Dix.

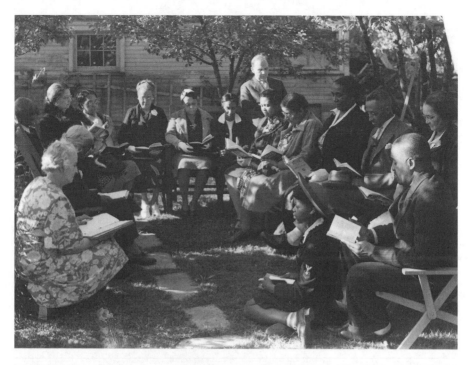

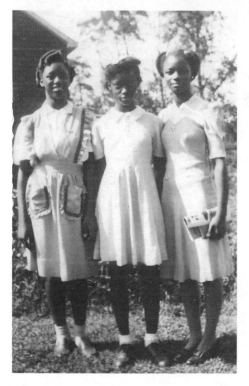

Above: Wendell's mother took her participation in church, through both the choir and Bible study, very seriously.

Left: Leona, Wilma and Lillie, as young women, beamed with pride and confidence based on their opportunities, education and hard work.

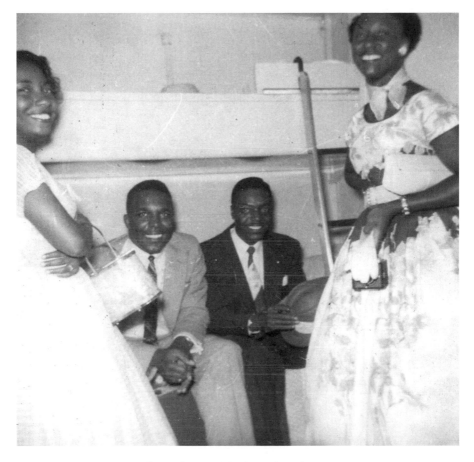

Leona, Obadiah and two of their friends visited a cruise ship.

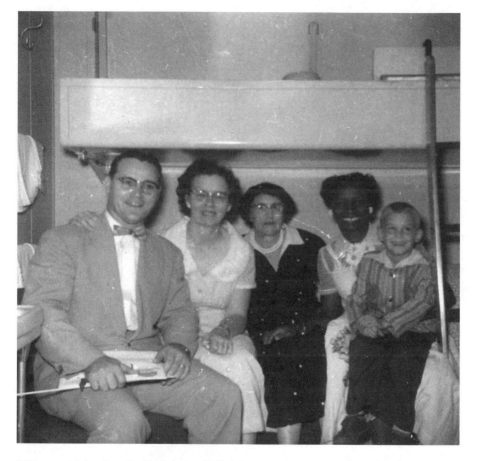

Lillie sat with her host family from her Fulbright program in Great Britain before she made her return cruise to the United States.

First Professionals

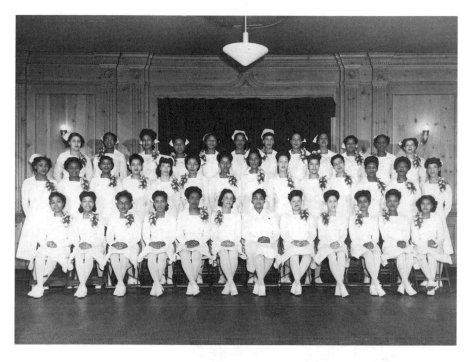

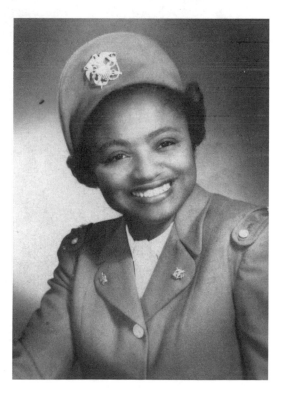

Above: The graduating class of Harlem Hospital's Nursing School in 1946. Marion was thirty-three years old in this photo.

Right: Marion served with the Nurses Auxiliary in the United States Army after graduation.

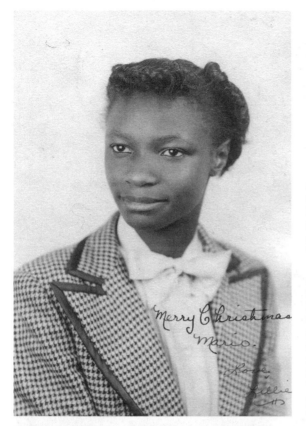

Left: Lillie completed her high school career at Freehold Borough and continued on to college, against the advice of her guidance counselor, at Trenton State College.

Below: When the family visited the Bronx one weekend, Marion took this picture of one of the city blocks. Many middle-class African American families owned homes in neighborhoods like this one in America's industrial cities. There was also a friend in the photo working as a nanny for a white family that day.

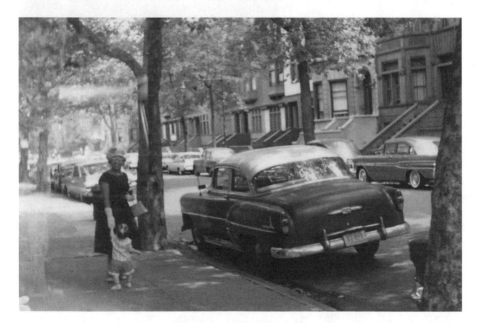

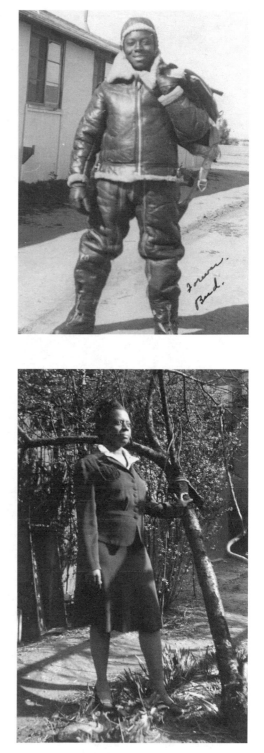

Walter Jr. served as an airman in World War II.

This image captured the intersection of the formal portrait with the informal snapshot. As the camera became more available, African American families used them to create photos that emphasized their dignity and determination without the artificial setting of a studio.

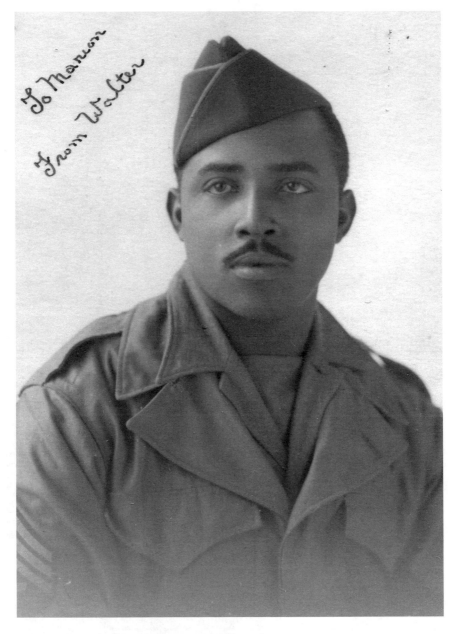

Marion's boyfriend, Walter, was another military man.

Silas Prepe was one of her favorite paramours. Here, he showed his bodybuilding skills.

A frontal view of Silas.

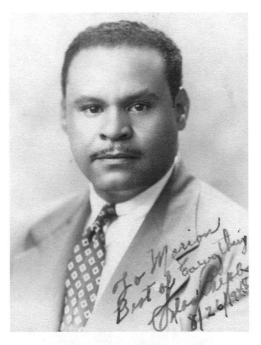

Silas dressed up quite nicely, too.

Marion returned to Freehold to work
as an elementary school nurse in 1956.

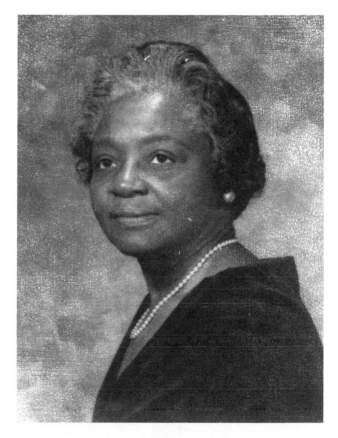

Right: Marion sat for her last formal portrait at her retirement from the Freehold School District in 1985.

Below: Marion, Celia, Walter Jr., Alma and Joseph surrounded Lilla for this family snapshot.

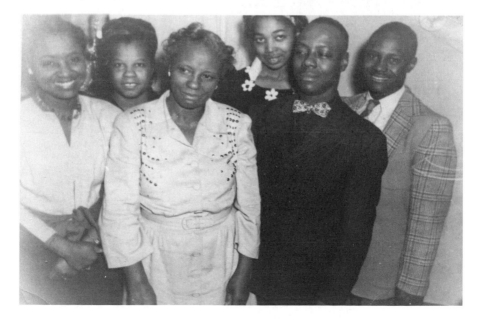

Walter Sr., Wilma and Lillie posed with a new red front door to the family's "dream home" at 125 Court Street. They were the first black family to acquire a home outside of the traditionally African American sections of the town.

Wilma took the oath of office when she became the first African American member of the school board in Freehold, New Jersey. Walter Sr. held the Bible for her ceremony.

Wilma jokingly held the "board" of education with a colleague at her first meeting. One of the other members did not seem to appreciate the humor of the moment.

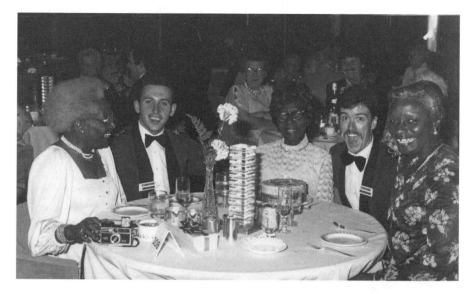

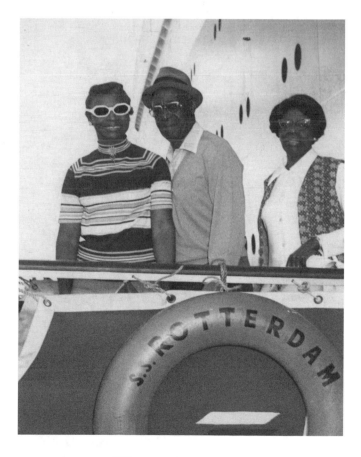

Above: Marion, Louise and Lillie shared a funny moment with their two waiters on a cruise.

Right: Lillie, Walter Sr. and Louise walked down the gangplank during their cruise on the SS *Rotterdam*.

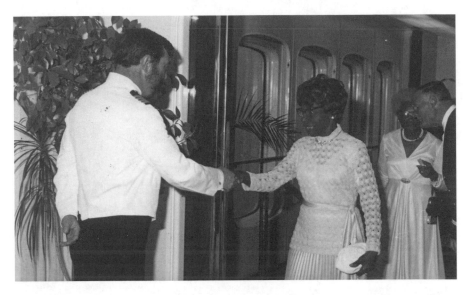

The captain of the *Rotterdam* greeted Louise as Marion waited her turn.

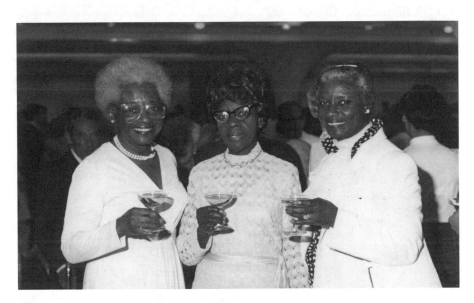

The three women toasted their success and the good life.

NOTES

CHAPTER 1

1. Gail Bederman, *Manliness and Civilization: A Cultural History of Gender and Race in the United States, 1880–1917* (Chicago: University of Chicago Press, 1995), 7–8, 12.
2. Becky Nicolaides and Andrew Wiese, eds., *The Suburb Reader* (New York: Routledge, 2006), 261–62.

CHAPTER 3

3. Wendell A. White, *Small Towns, Black Lives: African American Communities in Southern New Jersey* (Oceanville, NJ: Noyes Museum of Art, 2003), 69.
4. Gary Hunter, *Neighborhoods of Color: African American Communities in Southern New Jersey, 1660–1998* (n.p., 2002), 31–34.
5. Ibid., 63.
6. C. Eric Lincoln and Lawrence Mamiya, *The Black Church in the African American Experience* (Durham, NC: Duke University Press, 1990), 115–62.

Chapter 4

7. Kevin K. Gaines, *Uplifting the Race: Black Leadership, Politics, and Culture in the Twentieth Century* (Chapel Hill: University of North Carolina Press, 1996), 234–60.
8. Lizabeth Cohen, *A Consumer's Republic: The Politics of Mass Consumption in Postwar America* (New York: Alfred A. Knopf, 2003), 181–84.

Chapter 5

9. Myron Orfield, *American Metropolitics: The New Suburban Reality* (Washington, D.C.: Brookings Institution, 2002), 23, 49.
10. Robert E. Weems Jr., *Desegregating the Dollar: African American Consumerism in the Twentieth Century* (New York: New York University Press, 1998), 80–116; Manning Marable, *How Capitalism Underdeveloped Black America: Problems in Race, Political Economy, and Society* (Cambridge, MA: South End Press, 1983), 133–68.
11. Claud Anderson, *PowerNomics: The National Plan to Empower Black America* (Bethesda, MD: PowerNomics Corporation, 2001), 31–62; Thomas Sowell, *Basic Economics: A Common Sense Guide to the Economy* (New York: Basic Books, 2007), 495–517.
12. Marable, *How Capitalism*, 255–65.
13. Neil Postman, *Amusing Ourselves to Death: Public Discourse in the Age of Show Business* (New York: Penguin, 1986), 135–36.
14. Martin Luther King Jr., "A Revolution of Values," *Spirituality and Practice* (http://www.spiritualityandpractice.com/quotes/quotes.php?id=18695), accessed 14 May 2008.

About the Author

W alter David Greason is an associate professor of history and American studies as well as the coordinator of the African American and Africana Studies Program at Ursinus College in suburban Pennsylvania. He has published work on race, segregation and metropolitan growth in publications ranging from Planning Perspectives to the Journal of African American History to Next American City magazine. Greason is one of the nation's foremost experts on suburbs, especially in New Jersey, Pennsylvania and New York.

Visit us at
www.historypress.net